NORTH CAROLINA
TOBACCO

North Carolina
Tobacco

A History

Billy Yeargin

Charleston London
History
PRESS

Published by The History Press
Charleston, SC 29403
www.historypress.net

Copyright © 2008 by Billy Yeargin
All rights reserved

Cover design by Marshall Hudson.

All images are from the collection of the author, unless otherwise noted.

First published 2008

Manufactured in the United Kingdom

ISBN 978.1.59629.313.7

Library of Congress Cataloging-in-Publication Data

Yeargin, Billy.
North Carolina tobacco : a history / Billy Yeargin.
p. cm.
Includes bibliographical references.
ISBN 978-1-59629-313-7 (alk. paper)
1. Tobacco--North Carolina--History. I. Title.
SB273.Y43 2008
633.7'109756--dc22
 2007045006

Notice: The information in this book is true and complete to the best of our knowledge. It is offered without guarantee on the part of the author or The History Press. The author and The History Press disclaim all liability in connection with the use of this book.

All rights reserved. No part of this book may be reproduced or transmitted in any form whatsoever without prior written permission from the publisher except in the case of brief quotations embodied in critical articles and reviews.

This book is dedicated to all North Carolinians whose collective lives have given birth to an American tobacco culture.

Timing is everything. You came to my rescue and helped me focus on an issue that was long overdue. Special thanks to my friend and colleague Sondra Reed for your professionalism, dedication and guidance in formulating the nature of this project.

And to "Miss" Grace Barbour, without your enthusiasm and encouragement, this project would not have happened. You have my love.

"Miss" Grace Barbour, Wilson Mills, North Carolina. *Photo courtesy of Anna Bailey.*

Contents

Tobacco Days	9
Foreword, by Steve Troxler	11
Acknowledgements	13
The Beginning: There Were Marketing Pains	15
"The Duke Homestead," by Linda Funk	39
The Tobacco Auctioneer	53
A Story of the Tobacco Market Opening in Smithfield, North Carolina	63
Courier-Times Accounts of the First Tobacco Market Opening in Roxboro	73
"First Warehouse Believed Erected in Oxford in 1866," by Frances B. Hayes	79
"Tobacco Tales, Told from the Ground Up," by John Barbacci	85
"Tobacco, Seen 'from Other Side of Desk'"	101
"Tobacco Towns: Urban Growth and Economic Development in Eastern North Carolina," by Roger Biles	109
"Fifty Years of Tobacco: How Did We Get to Where We Are?" by John H. Cyrus	127
"Between You and Me," by Carroll Leggett	133
"Question & Answer with Pender Sharp," by Rocky Womack	139
"Hicks Honored by Stabilization," from *Flue-cured Tobacco Farmer* Magazine	145
"Remarks to Tobacco Workers' Conference," by J.T. Burn	149
Tobacco Terms	157

Tobacco Days

The rows almost ridge themselves, shaping the year again
 Toward seasons that let the dust of sandlugs
Fall into yesterdays lost in failed crops, quick dreams.

I lay on the warm ground of the Mayo barn at five in the
 morning
Hoping Brother would oversleep.
The flatbed trailer bounced across the ditch,
The Farmall Cub droned.
"Morning, boys." I climbed the tierpoles.
Taking the top, I handed down four sticks at a time to Lee and
Paul, who packed the trailer. From my perch I
Stirred the sun through airholes under the eaves.
The barn emptied, we walked through dew to breakfast.
Dreams drifted awkwardly, Brother's Big Man chew
Rolling over in sand-dust.

The tobacco greens for the farmer who dives into the dirt,
Renewed in the smell of warehouses,
Golden leaves in the light holes bringing the legged sunlight in.
Dew in dust, a musk in mist,
The tobacco tips one more time on the prime,
A sea of blooms
Bobbing in ninety-five degree wisps of heat,
Adhesive tape slipping over blisters.

Tobacco Days

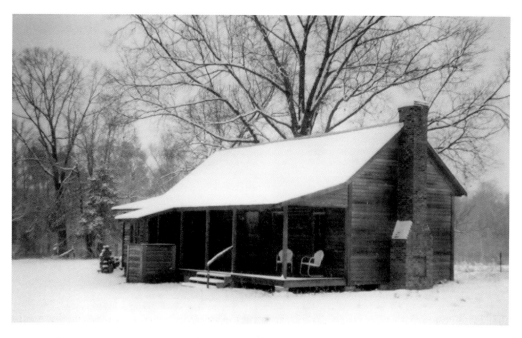

A wintry look at the homeplace of poet Shelby Stephenson, situated off the beaten path in lower Johnston County. *Photo courtesy of Shelby Stephenson.*

My bare feet burn on the ground and I shuffle
Toes into dirt for moisture, inching stalk by stalk
Down endless rows in the ten-acre field where short rows
Fade into plum bushes and shade.

The mules on the drags
Relax through the hot, climbing
July days, the frying dust, and you wonder if you'll ever
Get the gum off your hands.

—Shelby Stephenson

Note: Shelby Stephenson had been my friend for several years before I became aware of his wonderful artistic talents! Shelby, by many authoritative accounts, is one of the most effective architects of the English language and literature in the South. He is passionately engaged in his work at the University of North Carolina at Pembroke. Shelby's poetic skills are shown here as he reminisces on the tobacco culture that influenced him over the final decades of the twentieth century. (Taken From *Finch's Mash*, St. Andrew's College Press; reprinted with permission.)

Foreword

If knowing where you came from is as important in charting your course for the future as people say, North Carolina has much agricultural history and tradition to draw from. A big part of that history is our state's storied tobacco industry, which has been the foundation of our economy throughout the years and has been instrumental in shaping our great state and most of our major cities into what they are today.

Many families, many institutions and many towns owe a great deal to North Carolina's tobacco industry. I myself have strong ties to tobacco, being a tobacco grower for most of my adult life. I can tell you that this crop has helped me support my family, buy a house and some land and put two sons through college. I know plenty of other people who can say the same thing.

The tobacco industry in the state has changed greatly. I'm sure some of my predecessors would have a hard time imagining tobacco production without the price support system, and the growing season without the traditional warehouse auctions. Those, too, are now part of the industry's history.

I am committed to preserving North Carolina's agricultural history, including its tobacco history. I do believe we have much to learn from the past. One of the ways I have been involved in this effort is through the restoration of the wood-fired tobacco barn in Heritage Circle at the state fairgrounds in Raleigh. The past two Octobers, when the North Carolina State Fair rolled around, members of my staff, a hearty group of volunteers and I put in a barn of tobacco on opening day. By the end of the fair, the tobacco had finished curing and fairgoers could see the finished product. I intend to continue this new tradition.

The most powerful thing I am reminded of about when we put in that barn of tobacco is the strong feeling of community and cooperation created by everyone pitching in on a collective project. Make no mistake, it is still work. But for that one day, it feels enjoyable and a little less burdensome. It also rekindles many special memories of families and neighbors gathering at the barn to string and hang tobacco and serves as a bridge between generations of parents, grandparents and youngsters.

Foreword

North Carolina Commissioner of Agriculture Steve Troxler.

We need more reminders of those good times, of the sense of responsibility toward one another and of the strong work ethic inherent to farming. This is the story of North Carolina's people and the story of our communities, and it is one we should be proud to share.

In addition to the barn, I have also decorated the lobby of the Agriculture Building and my office with agricultural artifacts as a way to showcase and preserve the tools and implements of agriculture. I want people to know when they visit that they are in the Agriculture Building.

I commend Billy Yeargin's effort to preserve the history of tobacco in North Carolina. *North Carolina Tobacco: A History* shows Billy's passion and commitment to the preservation of our great and wonderful heritage. I join the industry's leadership in applauding his efforts and his commitment to this project.

Steve Troxler
North Carolina Commissioner of Agriculture

Acknowledgements

I am sincerely grateful to all who have given their time and support to this history and recollections of North Carolina's proud tobacco industry. It has been a worthwhile project, and indeed, a valuable education for me. All my life, I've been deeply embedded in American tobacco culture, but until I initiated this reflection on our tobacco heritage, I had not fully understood the extent of the "Pride in Tobacco" felt by grass-roots industry members across the state. This is especially true of those who, for most of the past century, have spent their lives in the tobacco fields, curing barns, packinghouses, tobacco warehouses and around the supper table after a long, hot day. Accumulatively, the tobacco workers are a fundamental product of the social and cultural influences of generations of families, loved ones, neighbors, communities and, as a whole, the Southeastern United States. I'm greatly impressed by their abiding affection for their tobacco heritage. There was always a gleam of pride in their eyes as the memories reached back to the hardships and good times experienced in surviving this "thirteen-month crop."

There are so many to thank, namely one of my best Johnston Community College history students, John Barbacci, who rendered a superb paper (included in this project) on the flue-cured tobacco loan support and control program, as well as "grass-roots" interviews. These interviews lend such a great cultural underpinning to this effort. I most especially extend my love and gratitude to the late Mrs. Grace Barbour of Wilson Mills, who spent countless hours poring over newspapers and other documented resources that were used in creating this wonderful story. Her support and dedication, which sometimes must surely have seemed both endless and hopeless, have been critical to the finished product. She was my guardian angel.

There are so many others, too numerous to mention, who have given precious time, materials and information to this project. But I would like to thank those who generously provided their financial support. Without their donations, there would have been no book. The major contributors include:

Acknowledgements

Frank Lee
Faye and Edward Stephenson
Tar Heel Farm Credit
BB&T
Deacon Jones
Southern States Cooperative
Leaf Tobacco Export Association
Smithfield Tobacco Board of Trade
Tobacco Association of the United States
Toby Lee
L.F. Mills
Leroy Moore
Leo Daughtry
White Swan Barbeque
Carolina Packers
WMPM Radio Station

I am much obliged to you all.

The Beginning:
There Were Marketing Pains

Archaeological discoveries reveal the herbal and medicinal qualities of the tobacco plant as one of the most critical factors in ancient global societies. Quite probably it was used in tribal rituals and religious ceremonies dating back to 3000 BC. Without question, however, it was used for these purposes as early as 800 BC.

Columbus recorded tobacco consumption among Native Americans when he landed here in the late fifteenth century. It was introduced to Spain in 1519. And in 1573, on his return from the Florida territory, Sir John Hawkins introduced tobacco to England for the first time. Sir Walter Raleigh is credited for introducing tobacco to the elitist circles of Great Britain when he returned from North America in 1585. In fact, England was already enjoying tobacco pleasures when Raleigh returned from the Carolina coast. His only contribution was to give prominence to the art of smoking a pipe. However, Raleigh's great name and celebrity status drew more attention to tobacco habits than someone who might have been less notable.

Even during this era, tobacco lacked public respect. King James, for example, suffered with an extreme distaste for it. In 1604, he issued his famous "Counterblaste to Tobacco," warning of the detriments in consuming this "foul herb." But even he enjoyed the economic abundance of it.

The first tobacco industry on the North American continent was started in 1612 by John Rolfe. Rolfe, more widely known as the husband of Pocahontas, shipped two hundred pounds of native tobacco from his James River farm to England. The English, who had traditionally been at the mercy of Spanish tobacco prices, immediately responded with demands for more. Knowing he would ultimately have to compete with Spanish trade, Rolfe smuggled the sweeter and milder strain of seeds from Varina, Spain, into the colonies. With great ingenuity and determination, he began producing a more desirable product. Demand from Europe rose even more. As a commemorative gesture, Rolfe named his plantation Varina Farms. Though tobacco has not been produced there in almost three hundred years, Varina continues to be a working farm today.

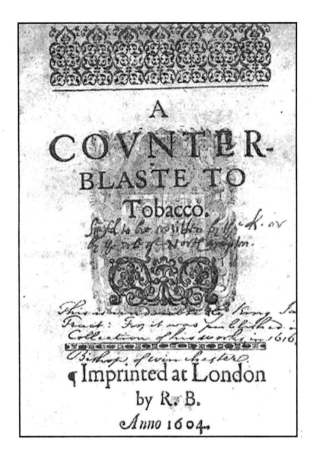

"Counterblaste to Tobacco," issued by King James in 1604.

After four previous failed attempts, Rolfe's pioneer commercial venture reversed the fate of the colonists' effort to settle on American soil from failure to success. Thus, the British government enjoyed its first success in establishing a new colony on another continent. Tobacco trade from Jamestown made the difference. Upon returning from his first trip to England in 1616, Rolfe discovered tobacco growing all over the Jamestown settlement, even in the streets, and as far west as present-day Richmond. Colonists began to neglect planting much-needed food crops. Consequently, this mandated the first governmental intervention. In 1616, the deputy governor of Jamestown sought to balance the settler's obsessive tobacco production by prohibiting anyone from growing it unless he grew at least two acres of corn for nourishment. At least to some extent this act provided better variation in agriculture production and encouraged the population to reap a broader subsistence from the new land. However, the New World responded to England's skyrocketing tobacco demand with increased production of this different form of "gold."

The colonies weren't yet capable of manufacturing utensils, implements, foods, clothing, home supplies or other necessities. Industrially, England was centuries ahead and it provided a natural trade forum for colonial bartering in export/import goods. The stage was set for a "goods and service" trading environment between planters and Europeans.

The Beginning: There Were Marketing Pains

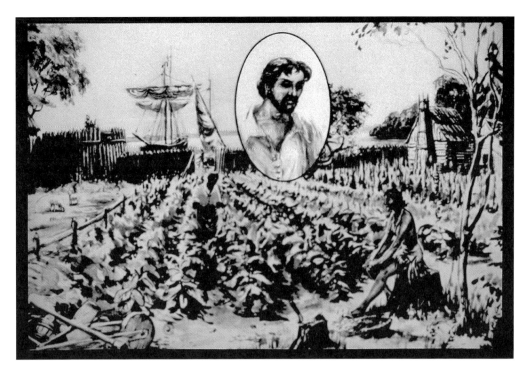

John Rolfe is depicted as supervising cultivation of his tobacco crop at Varina Farms, west of Jamestown and about nine miles southeast of what is now Richmond, Virginia.

Until the mid-eighteenth-century French and Indian War, there was no coinage or paper currency in the colonies. Being of such great and consistent colonial value, tobacco became a necessary substitute. The process wove its way from the planter to the merchant and then to exportation. Planters were extended credit for tobacco production, and at the point of sale, all debts were paid in pounds of tobacco. Then the cycle would repeat itself: i.e., the planter reentered into debt to the merchant for the cost of another crop, plus additional goods. He would remain in debt until the next crop was sold. In turn, the merchants receiving the tobacco engaged in European trade for imported goods and, again, supplied the planter for another crop year.

Tobacco was usually delivered at a wharf (otherwise referred to as a rolling house, tobacco magazine or storage house) located at a convenient and suitable port along the river. It was packed tightly in various sized barrels, called hogsheads. Each end, or head, of the hogshead was reinforced to accommodate insertion of a stout pole into one end, through the middle and out the other end. Enough of the pole protruded out of each end to allow attachments for pulling the hogshead, in a rolling fashion, to the shipping point by oxen, horse or other means. Upon possession by the merchant or receiver, a tobacco note was given to the planter, who then used it to pay his debts. Soon he discovered that, as a rule, the merchant didn't thoroughly probe and examine the goods inside the hogshead. Instead, he placed it onboard the ship destined for England along with the other cargo.

North Carolina Tobacco

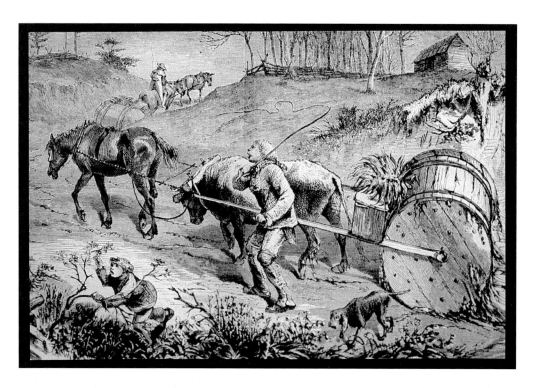

Above: A planter taking tobacco to the port nearest his plantation. Tobacco is inspected, weighed and then put aboard a ship bound for European merchants.

Left: Even though the waterways provided the general mode of seventeenth-century transportation around Jamestown, Virginia, settlers who grew tobacco farther inland used barrels and wagons to move tobacco to the wharfs or ports. Many present-day roads in North Carolina and Virginia were carved out by these settlers as they took their tobacco to the waiting ships.

The Beginning: There Were Marketing Pains

The merchant's nonchalant attitude in assuring the quality of his newly purchased goods invited a practice among planters known today as "nesting." "Nesting" tobacco simply means placing the good quality tobacco in the top of the hogshead and bad quality at the bottom or deep inside to conceal it from the merchant. Thus, even if the merchant should question the integrity of the planter and look inside, he surely wouldn't tear it apart and waste a lot of time trying to qualify it. By 1619, nesting had risen to such proportions that English customers began complaining to colonial merchants and to British authorities. This resulted in the second government intervention of regulation for New World tobacco producers. This was the first general inspection law, passed by the House of Burgesses, mandating that all tobacco offered for exchange and found to be "mean" in quality by the magazine (warehouse) custodian be burnt. In 1620 and 1623 the inspection law was amended to provide for the appointment of sworn men in each settlement to condemn bad tobacco.

In 1630 a companion act was passed prohibiting the sale or acceptance of inferior tobacco in payment of debts. A commander stationed at each plantation or settlement was authorized to appoint two or three competent men to help him inspect all tobacco offered in payment of debts. If the inspectors declared the tobacco's quality to be mean, it was burnt and the delinquent planter was barred from planting tobacco. Only the general assembly could lift this disability. From 1619 through 1785, Virginia passed numerous laws to protect the purchaser from being victimized by nested tobacco, but none were effective. With each new law the planter created more discrete and innovative methods. Being aware of this persistent and damaging practice, and not having the collective defense against it, the merchant responded by dropping the value per pound.

Sir Francis Wyatt attempted to deal with the problem by reducing the yield per planter. In 1621 he mandated that each planter limit production to one thousand plants with no more than nine leaves each, or a maximum net yield of 100 pounds. The effort was designed to discourage the planter from bringing a larger and more bulky hogshead port. The planter easily found ways to circumvent this new mandate and soon Wyatt's order was rescinded. In 1629 the maximum cultivation each planter was allowed rose to three thousand plants, plus an additional one thousand for each nonlaboring woman and child. By this time the export figure had climbed to 1,500,000 pounds.

As with any social and economic phenomenon, the situation required some form of order, authority and organization. If colonization was to be permanent, clearly the structure of the trade must be designed to ensure social and economic progress, not just for the colonist, but the European investors as well. Colonial tobacco production was the major influence in geographic expansion along the rivers and bays of the Virginia Peninsula, the Carolinas (or Rogues Harbor as the seventeenth-century Tarheel area was referred to) and into the Delmarva (Delaware-Maryland-Virginia) Peninsula, then northward into Pennsylvania. Production was demanding on coastal soil and no effective fertilization plans or agronomic instructions were available at the time to replenish the soil from one year to the next. In order to get a satisfactory crop yield, the planter was forced to relocate and clear new fields every two or three years. Aside from the movement northward and southward, many gathered up their families and laborers and moved westward into inland areas.

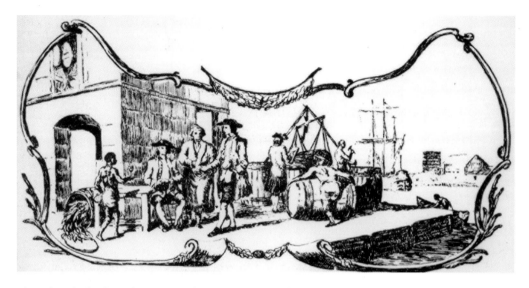

The colonial wharf was the seventeenth-century version of today's tobacco warehouse. It is where the "American Tobacco Culture" manifested itself…the gathering place for settlers to discuss important issues such as the value of their crops, politics, social and civic matters. It was also where the value of the crops was decided.

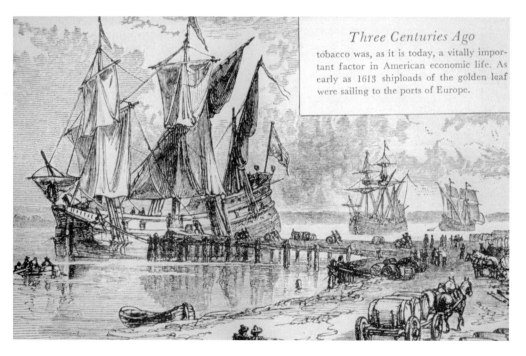

Three Centuries Ago.

The Beginning: There Were Marketing Pains

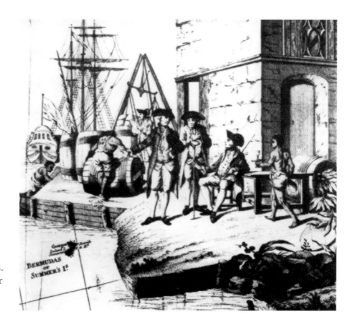

Those who owned deep-water ports enjoyed extra value by amassing several smaller crops into one shipment to European markets. This was where many disputes over the value and integrity of the crop occurred.

Other factors also promoted expansion, including the planter's need for enough "elbow room" between himself and authority. As tobacco production began saturating the area, the abundance of navigable rivers up and down the eastern coast offered flexibility in choosing new areas of production. In a few short decades after Rolfe's great entrepreneurial venture began, tobacco dominated and molded all mid-Atlantic social and economic life. It regulated the life of all commercial interests more than any product of a modern community.

In 1633 tobacco became the basic measure of value. Paradoxically, that same year it was demonetized by an act of the assembly, but the act was completely ignored by the people. A repeal in 1642 restored tobacco as a monetary factor. Thereafter, only debts contracted in tobacco were recoverable by law.

The golden leaf was accepted as payment for taxes, purchasing wives and even as payment to preachers and the settlement guards (the military). In 1660 the Lord Proprietors of Carolina organized a plan to officially colonize what is now North Carolina. King Charles II granted a vast area from Spanish Florida to the southern border of Virginia and from the Atlantic to the Pacific, to become the Carolinas. One condition of that grant was that settlers of this area would not produce tobacco. This was done largely to appease Virginia and Maryland leadership, who complained that opening up territory to the south, would only add more trade competition and increase the already over-produced crop. However, settlers seeking new tobacco soil had already entrenched themselves in the "Rogues Harbor" area and had begun tobacco production before Charles II granted the colony. The increasing movement to the outskirts of settled territory, along with the ingenuity of planters, gave constant and effective resistance to the regular barrage of laws dealing with nesting tobacco. By 1644 the practice was so obvious that merchants and dealers collectively turned to English rule for assistance in

arresting the problem. Planters had begun to hide tobacco stalks, tree leaves and other worthless objects deep inside hogsheads. Even liquor, starch and spikes were retrieved when the hogshead was opened at its final destination. Any bill Parliament could produce only served to sharpen the planters' imaginations.

In 1666 Virginia leaders convinced producers in the Carolinas and Maryland that supply was exceeding demand and that it would be in the interest of all tobacco colonies to abstain from production for one year. An agreement was made to this effect, only to be vetoed by Lord Baltimore. Carolina planters responded to the veto by opening up more cultivatable land below the Virginia border. In 1669 the Albemarle Assembly of North Carolina passed a law designed to attract more settlers into Carolina. Virginians, already hostile to the Carolina settlers because of increased trade competition, passed a law in April 1669 that prohibited tobacco from being shipped directly out of the Carolina Colony into Virginia or other trading areas. For the one hundred years that this act remained in place, "Rogues Harbor" ignored it, and the Southern colony's tobacco trade felt no real effect from it. The planters were as astute at smuggling into Virginia, or bypassing Virginia's patrolling forces, as they were in continuing to nest tobacco. By 1731 London's Privy Council finally recognized the economics of commerce in the Carolinas and repealed the law of 1679. Even so, all tobacco produced, whether in Virginia or Carolina, was referred to as "Virginia" tobacco.

Between 1619, when the first law dealing with nesting tobacco was imposed, and 1730, numerous legislative efforts were brought forth to deal with the issue. All inspection laws passed between 1619 and 1641 were repealed, except the Act of 1630, which prohibited the sale or acceptance of inferior tobacco in payment of debts. The Act of 1630 remained in force until 1760. In 1723 the general assembly passed an act authorizing the county courts to build warehouses at public expense. For the sake of expediency and to ensure closer observation and policing of inspection laws, these were to be built within a mile of a public port or landing. Governor Spotswood of Virginia introduced an act requiring licensed inspectors at warehouses. This act was opposed by Colonel William Byrd and ultimately vetoed by the Privy Council of London.

Colonization of the New World was moving into a second century. The vested interest of European financiers and governments were being born from the colonial tobacco fields. And greed was deeply ingrained through this trade. Regulation and government enforcement, designed to ensure maximum profit for the mother country, was made difficult because of the distance between the governed and the governors. Even with regular visits and monitoring by English rule, as well as a host of appointed colonial authorities, it was impossible for the Crown to maintain an objective view of the day-to-day business proceedings on American soil. While nested tobacco continued to pour into Europe, the distance and lack of perception of the nature of the proceedings at the local level rendered the Crown unable to comprehend a true formula for correction. That, to a large extent, was left to local authorities, who even at close range had serious problems dealing with this persistent problem.

In 1730, after 110 years of legislative failure, the Virginia General Assembly passed the most comprehensive inspection bill ever introduced. In part, it provided that no

The Beginning: There Were Marketing Pains

The last remaining colonial tobacco warehouse, or as it is sometimes referred to, wharf, or "magazine," in Urbana, Virginia. This building, erected sometime between 1690 and 1710, now houses a library.

tobacco was to be shipped to England in hogshead cases or casks without having first been inspected at one of the legally established warehouses. Two inspectors were employed at each warehouse, and a third was summoned to settle disputes between the two regular inspectors. These officials were bonded and forbidden, under heavy penalty, to pass bad tobacco, engage in tobacco trade or take rewards. Tobacco offered in payments of public or private debts had to be inspected under the same conditions as that to be exported. The inspectors were required to open the hogsheads and extract and carefully examine two samples. All trash and unsound tobacco was to be burned in the warehouse kiln in the presence of the owner and with his consent. If the owner refused consent, then the entire hogshead would be destroyed. After it was sorted, the good tobacco was repacked and the planter's distinguishing mark, the net weight, tare weight and the name of the inspector and the warehouse were stamped on the hogshead. In part, this act was a desperate effort by the government to lay to rest, once and for all, the planter's bad habit of nesting. Also, for the first time, this act addressed the increasing need for a more orderly marketing system.

Europeans who, for many reasons, were dissatisfied in the mother country and who had heard about the promise of riches from tobacco production in the New World, opened up a continued wave of migration into Virginia's tidewater and Carolina's coastal area. By the turn of the eighteenth century, tobacco exports from Carolina had

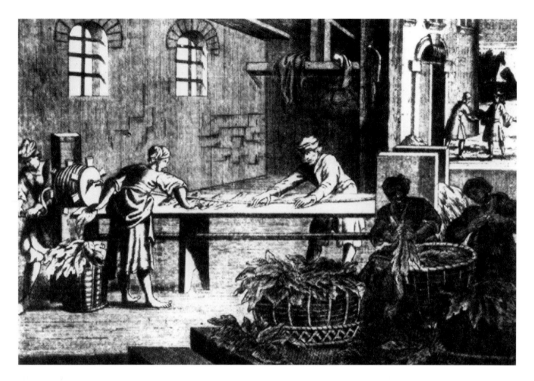

Tobacco being prepared for market. In some cases, this process was done before the tobacco was presented for inspection. In others, it was done after purchase by the local merchant who, in turn, loaded it for passage to Europe.

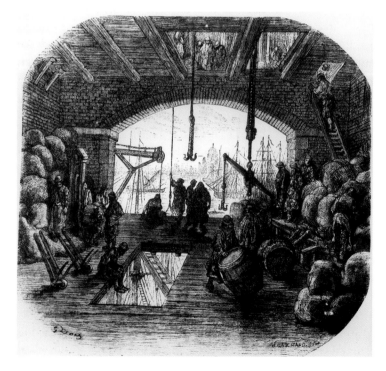

While production and marketing of raw tobacco flourished in the colonies, processed tobacco became a tremendous business in all European areas. Here is a scene of a tobacco-receiving warehouse on the Thames River in England.

risen to eight hundred thousand pounds annually. Combined exports out of Virginia and Maryland and into Europe were now exceeding twenty-two million pounds. Along with this trend in production volume came the intensity of the nesting problem. The Carolina colony, now rapidly becoming a major tobacco exporter out of Port Roanoke (Edenton), suffered the same nesting problems as its neighbors to the north. Tobacco shipped out of that port to Scotland was perpetually nested with undesirable materials. Inevitability, Carolina would be forced to adopt an inspection act of its own in 1754. Like all others before, these comprehensive bills failed to bring real relief to the nesting problem.

While marketing began to take some form of order and organization, disputes over quality and prices persisted between seller and buyer. The buyer would use price reduction to offset against the prospects of receiving undesirable tobacco. The planter would cry foul. The government inspector would intervene and attempt to settle the matter. As nature has it, the inspector often yielded to the side that was the quickest to discreetly pass along covert financial rewards to supplement his meager government pay. This practice, like nesting, pretty soon became general knowledge around the inspection stations. As the late eighteenth century approached, the Act of 1730 and its Carolina companion law of 1754, just as all past efforts, became a helpless tool in tobacco inspection. Inspectors lost credibility with both the merchant and planter. Both often demanded reinspection by someone whom they held in higher esteem and who appeared to be more competent in the judgment of quality leaf. This swelling distrust in trading circles ultimately led to a decrease in the value of the tobacco note.

In some cases during the mid-eighteenth century, buyers and sellers regarded each other as men of integrity and honesty. Consequently, they were both comfortable making "private agreement" purchases on the plantation, then settling all debts on the spot. If a dispute arose under these circumstances, two reputable and competent neighbors were summoned to solve the matter. This type of trade arrangement diminished the importance of government inspectors. Yet, well into the latter part of the eighteenth century, inspection stations were the dominant point for tobacco exchanges. By 1775 the Inspection Act of 1730 was rendered useless in ensuring honest trading at these points, and the act was repealed. For the next year plantation purchases increased and the merchant himself was the inspector. Alternatively, the merchant would visit the warehouse during the official government inspection and seek out the owner of the better quality tobacco; then, without using the judgment of the inspector, he would make a private offer. The popularity of this method soon attracted planters to warehouses frequented by the great number of merchants. This new twist seemed to bring higher tobacco prices than those under the inspection process. Independent market houses, open street markets and warehouses began to appear in small towns and settlements throughout the tidewater areas, and by 1810, as far west as Lynchburg, Virginia.

At this point five ingredients of the present-day tobacco auction system were now in place: warehouses, which were established by the Act of 1712; the Act of 1730, an attempt to assure fairness in trade; the displaying of tobacco to attract merchants; the beginning of small market towns; and commercial demand. These factors continued to play a major role in shaping the structure and economic growth of Colonial America.

Singularly, tobacco commerce had already greatly influenced European attitude toward the colonies. The demand in England for American tobacco products, tax revenue gains and the assurance given European investors, whose lots were cast on the New World, all stemmed from the golden weed. The thriving new North American settlement had earned the status of favorite son to the British.

In 1775 the colonies joined together and declared independence from English rule. Again, tobacco proved its value. Under the leadership of Thomas Jefferson, a tobacco farmer from Charlottesville, Virginia, the first Continental Congress was formed and the militia was nationalized; under the leadership of George Washington, a tobacco farmer from Mount Vernon, Virginia, battles were fought and won, and thus we became a free society. Tobacco was the primary source of collateral offered by Benjamin Franklin when he turned to France for a loan to underwrite our transformation from three centuries of English bondage to a self-governed nation.

Now under domestic rule, tobacco had gone through several phases since the time of the early Jamestown settlement, but problems had influenced the appearance of markets in towns on the western perimeter of civilization. With eighteenth-century decline in tidewater production came the decline in government inspection warehouses. The adventurous sector of the producing population was moving westward. Inspection station numbers were declining, not just in the tidewater area, but in general. Just before 1800, there were seventy-two official inspection stations in Virginia, thirteen of which had been shut down by 1810. Fifty-four were concentrated around Richmond. In 1816, 90 percent of tobacco brought to market was inspected at the Richmond, Petersburg or Lynchburg stations. Commerce continued a slow westward and north–south movement. Simultaneously, tobacco trade began concentrating into fewer towns.

Tobacco in Antebellum America

After the War of 1812, speculation in tobacco trade took a sharp turn upward. The speculator was quite adept at sensing good deals as they arose. He knew how to buy at a low price, then quickly sell at a high price and avoid any significant overhead cost. Inspectors, while legally forbidden to engage in speculation or any other practice that would hinder their objectivity or fairness, had for some time been very discretely involved in tobacco speculation without having their hand called by the public or government. For two centuries they had either been too discrete to be caught red-handed, or they engaged themselves in bits of underhanded monetary trade-offs. Both planter and buyer claimed to have suffered at the hand of the inspector. This, along with the natural marketing evolution, gave birth in some market towns to an attractive new sales twist used by French marketers for ages: the auction method of selling.

Some planters brought their crop to market and independently sought for themselves the most appealing price. Some cried out for bids on their own tobacco, or employed someone else, perhaps the inspector, to do the job. The intent was to establish competition among purchasers. At first this new "auction" approach was not practiced

in all markets. Soon, though, it began spreading into wider areas. It was not a "catch-all" solution to many persistent marketing problems; however, by law, inspectors could not engage in crying the bid for anyone with whom he had financial connections, unless (as the law stated) he was asked by that person. This legal loophole protected his illicit practice. By the mid-1820s, private auctioneers begin advertising themselves for hire at warehouses. The first of these was H.B. Montague of Granville County, North Carolina. In November 1827, Montague grasped the opportunity by advertising himself in the *Richmond Inquirer* as an "Independent Tobacco Auctioneer, one of integrity."

Technically, others before him had "auctioned" tobacco, but Montague's public announcement set a precedent that changed the buy/sell arrangement at the marketplace. This paved the way for any talented and aspiring entrepreneur to enter the marketplace and, for a fee, represent the planter without government scrutiny. With this new approach came the demise of the primary role of the government-sponsored inspector.

The seller sought the market hosting the largest number of buyers and the most competitive atmosphere. There he hired an auctioneer to cry the bid for his crop. Since the buyers were beginning to conduct their own inspections before bidding, the inspector himself was becoming less and less a part of the process. The inspector then saw the potential of the dual role: in addition to his government responsibilities, he could act as an inspector/crier as well as a commission merchant. Virginia law continued its attempt to deal with the illicit practice of inspectors to allow broader leverage. He could now operate either as an inspector or auctioneer, whichever yielded the highest revenue.

As expansion occurred, marketplaces followed. And as marketplaces sprung up, economic growth was established, accompanied by increased population density. The domino effect proved to be a great force in the continued process of opening new territory. Transportation on rivers, canals and roads traversed by tobacco hogsheads made expansion easier and more expedient. As new settlements sprang up and markets multiplied, inspectors became more numerous. Political influence among planters and merchants was an inherent ticket to receiving an appointment as a colonial inspector. After all, in a society that depended solely on the price of tobacco, who else could invoke such an impact on the life of a planter or merchant? In human terms, this government official embraced an enviable position. His judgment could make or break a planter in a moment's time, or could rob the merchant of his profits by the very attitude by which he surveyed the contents of a hogshead. He enjoyed a disproportionate share of public weight.

As tobacco production drifted out into the westernmost edge of civilization, new market areas were created and warehouses were established. The results, almost without fail, were that small villages and towns were formed, and in many cases eventually grew into great expanses like Richmond, Lynchburg, Fredericksburg, Petersburg and Manchester, Virginia; Annapolis, Maryland; and other metropolitan areas. All were born of the tobacco trade.

By the mid-1830s, the concept of selling to the highest bidder using an independent "crier," or like Montague, an "auctioneer," came to be construed as a possible solution to the age-old problems between buyer and seller. Marketing leadership on both sides

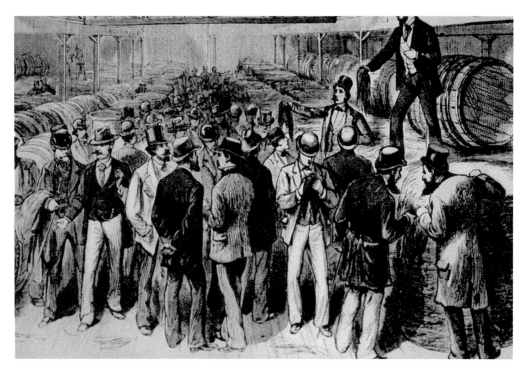

A depiction of an antebellum tobacco sale, probably in Lynchburg, Virginia. The scene illustrates the method of tobacco sales involving an independent "crier" seeking to excite potential buyers with "the goodness of gold."

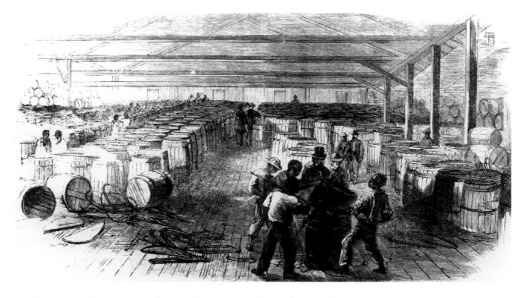

An illustration of preparing, or "prizing," tobacco in the Seabrook Tobacco Warehouse, Richmond, Virginia, circa fall of 1865.

began looking upon this as a preferable alternative to the older process of meeting in the town square, presenting the goods and having the government inspector judge the quality and, finally, closing the sale. The auction method contained several attractive elements that helped it gain popularity among all factors of the trade. Even before the rhythmic chant of the auctioneer, the inspector, who continued to evolve into the role of "crier," created excitement in his attempt to stir competition between buyers. His form of entertainment to the gathering street crowds offered a bit of curiosity to a budding new village or town, which otherwise sorely lacked amusement facilities. This early stage of auctioneering enhanced competition among buyers, who heretofore had used private bartering or "barn-door" buying at the plantation and other private means of purchasing. The buyer's approach had been to negotiate in private, thus eliminating public competition. The auction offered buyers easier and more consolidated ways to make purchases. He didn't have the expense and time-consuming trouble of traveling into widely spaced towns and villages to fill his needs. The added feature of free street entertainment kindled the fires of change from the old way to the new. It is safe to say that the old trading method, based on government inspection, as well as the newer methods of private merchant inspection and auction, plus the increase in demand for tobacco and the ensuing demand for additional marketplaces, played a major role in establishing many of today's eastern seaboard towns and metropolitan areas.

Even though the traditional inspection system remained intact long after the auction method emerged, it began to be more and more concentrated in geographic sections. The novelty of the auction spurred new market towns and gave a shot of adrenalin to areas that had been slow in growth. In 1838 a new "flue" method of curing tobacco was accidentally discovered just below the Virginia border in Caswell County, North Carolina. Flue-cured tobacco, unlike that which had been historically dark in color, was bright yellow and immediately brought more profit at sale than did the darker tobacco. This discovery on the Abisha Slade farm probably caused as much excitement in tobacco commerce as any single incident since the 1613 birth of the industry. With the population increase, simultaneous increase in tobacco consumption and the discovery of a new kind of "bright" tobacco, production made a sharp turn upward.

Expedience on the sale became a critical factor. Heretofore, sales were relatively uneventful in terms of marked excitement: the planter brought his crop to the marketplace and the merchant looked it over, or where government inspectors were still available, it was inspected. Then the inspector/crier took bids on behalf of the planter. Offers were made, accepted or refused and the transaction was completed. Now the trend was moving to faster sales. Also, with the gradual diminishment of public inspections, merchants were more cautious in protecting themselves against bad tobacco. Private warehouses, now in the majority over government houses, were responding by holding "loose-leaf" sales. The loose-leaf sale, of course, meant that instead of bringing tobacco to market in hogsheads or casks, the planter had to present it in loose or unprized (unpacked) form. It was easier to inspect in its entirety this way.

Loose-leaf sales followed close behind the auction method, and in 1858 the first full-time loose-leaf tobacco warehouse was opened in Danville, Virginia, by Mr. Thomas

Neal and Associates. This launched the contemporary method of tobacco sales and became known as the Danville System.

The Danville System, while setting another marketing precedent, didn't eliminate the old method, which remained for decades to come. Tobacco production had moved westward into Kentucky, the Midwestern states and as far west as the Mississippi River, and had been broken down into various types. The different types depended on location of production, kinds of soil in which it was produced and method of curing—artificial heat (flue-cured), air-cured, sun-cured or fire-cured. Selling under the old method or new was determined by all these factors, plus the mandates from state governments and the wishes of those affected on a local scale. However, flue-cured tobacco has been sold under the loose-leaf auction system since opening day of Neal's warehouse in Danville.

The concept of the loose-leaf auction, suggested by some historians to be the brainchild of a Dr. J.B. Stovall of Halifax County, Virginia, not only served the cause of expediency, but more effectively served to correct, or at least arrest, many discrepancies within the marketing system. As noted, the practice of auctioning had been used for some time already. In Danville, for instance, it had been experimented with since 1837, but it wasn't used exclusively. Neal and his associates had to canvas all tobacco production areas and convince farmers to try the new auction system. He claimed, quiet correctly, that his new way of marketing would eliminate many of the aggravations from the old way. For example, it would offer immediate pay to the farmer after the sale, instead of the old way of having to wait for pay, and a keener air of competition. At the same time, it would eliminate the laborious job of prizing tobacco, and it would also impose a fee to be paid for inspection. In 1860, Neal obtained authorization from the Virginia General Assembly to inspect tobacco and impose a fee on the farmer. For the buyer, the advantage lay in the fact that tobacco was in loose-leaf form and the risk of nesting was less than in prized tobacco. Neal and his associates also pointed out that the buyer had a better grade of tobacco to choose from since his method of sales would entice farmers to bring their entire crop, including the best available, to Danville instead of Richmond, Petersburg or Lynchburg. On June 6, 1872, a new regulation was passed that was designed to help the federal governmental collect taxes from all tobacco dealers. It stated that every farmer had to furnish, under oath, a correct statement to the government of all sales of leaf. This was another incentive for farmers to sell at an organized auction.

The outbreak of the Civil War, however, virtually disrupted public trading of tobacco. But, thanks to both Southern and Northern soldiers who had pilfered through the Southland's storage houses, barns and packinghouses and stolen tobacco, a significant increase was seen in postwar tobacco demand. As soon as the war ended, they began sending orders southward for more.

Of course, rising demand begat rising production and marketing. And the ever-increasing importance of tobacco was felt at rural crossroads throughout the South. Historically, farm to market transportation was mostly limited to wagon roads and canals. Farmers themselves carved out many market roads; community volunteers carved out a few; and some were etched out by counties and the state. But tobacco progress demanded an increase of better and faster market routes. With demand increasing

and warehouse numbers rising in both Virginia and North Carolina, warehousemen were the most influential in local and state politics. Realizing their own vested interest in promoting better transportation, they began putting increased political pressure on state and federal representatives to build railroads that were convenient to their places of business. Not only did these open up small towns and give better access to the larger industrial centers, but they also provided better and faster transportation to tobacco manufacturing centers. Other types of commerce benefited from the modernization of transportation as well. Thus railroads systems, built primarily to expedite transportation from outlying areas into manufacturing facilities, served to bring a sparsely populated mid-nineteenth-century society closer together in commercial trade.

As Tobacco Grows, So Does the Community

Along with the intensity of tobacco trade came support trade. As transportation became faster and easier, supply trading and gathering of civic and business interests began increasing. Tobacco towns grew at a rapid pace. Educational, religious, civic and business interests took root, and in many areas, such as Durham Station, where only a crossroads once existed, a thriving community was established. Today there are many examples of the influence tobacco marketing had on the success or failure of a community struggling to become an important locale for trade. Milton, North Carolina, located just south of the Virginia line, is one example. Its economy was bolstered by a nineteenth-century tobacco market, but when the market closed, the village growth was stunted with only a handful of inhabitants. Today it is still the same size as when the market closed down. Another example is Youngsville, North Carolina, which suffered the same fate as Milton. Durham, North Carolina; Richmond, Lynchburg and Petersburg, Virginia; Winston-Salem, North Carolina; and many other cities display undisputed examples of the success a continued tobacco market brings. Smaller tobacco market towns, such as Oxford, Henderson and Roxboro, North Carolina; Clarksville, South Boston, Farmville and Chase City, Virginia; Mullins, Loris and Timmonsville, South Carolina; Tifton, Douglas and Valdosta, Georgia; as well as small markets in Florida, are good examples of villages started by tobacco markets that have grown to comfortable proportions over the past century and a half. They are all still tobacco markets today.

Tobacco warehouses, while built primarily for the purpose of organizing and selling large volumes of tobacco, served multiple purposes. In most cases they were the only facilities capable of hosting larger crowds. Thus they served an assortment of public events, such as political gatherings, religious services, rallies and official public meetings. After the dominance of the loose-leaf auction became established, warehouses were built on a much larger scale, with huge doors, windows and skylights and covered driveways for loading and unloading. This was unlike the old tobacco exchange where only samples were brought inside for inspection while the remainder of the crop waited outside on carts or wagons. They also had overnight accommodations, which attracted farmers who lived more than a comfortable day's distance from the market.

Initially most were built of wood, but later in the eighteenth century brick was used for construction. Warehouses often covered acres of land. The owners then used the enormous size as an advertising factor. David Y. Cooper of Henderson, North Carolina, one of the Old Belt's more innovative and knowledgeable tobacconists, illustrated his creativity in cutting the cost of building a new brick house in the early 1880s by inviting his friends and customers to contribute a brick to its construction. Cooper's enthusiasm was such that most brought full carts and wagonloads. Consequently, materials for outside construction were mostly free and capital investment was at a minimum. Allen and Ginter, Richmond's leading cigarette manufacturer, brought a marble slab with gilt tobacco leaves and an appropriate inscription. Earlier warehouse facilities were used for military musters before and during the Civil War. In 1919, a new and short-lived tobacco market was opened in Statesville, North Carolina. Contemporary observers remember that, upon completion of the warehouse there, the greatest Fiddlers Convention in Statesville's history was held under its roof, and even today it is regarded as having been a great source of local pride. During World War II, warehouses were used for rallies to encourage the sale of Liberty Bonds to assist in underwriting the war.

When Federal troops entered Richmond in 1865, warehouses were seized and used for storing various federal government items, as well as for incarcerating Confederate soldiers. Washington Duke was among the unfortunate prisoners. He was routed from imprisonment in Richmond's famous Libby Tobacco Warehouse to New Bern, North Carolina, before being released to walk home to Durham Station.

Even today, tobacco warehouses in smaller towns are used for community gatherings of any significant size, including agriculture trade shows, school dances and such. With the end of the Civil War came Reconstruction, along with the rebuilding of the South. Six months after Lee surrendered to Grant at Appomattox, warehouses renewed their trade in Danville and immediately tobacco manufacturing began there. One after the other, auction houses appeared in areas where tobacco's financial stability became more and more apparent.

This loose-leaf method, or as it was called at the time, the Danville System, caught on like wildfire and other villages fell in line. Durham opened in 1870. Reidsville, Winston and Henderson followed closely behind. Durham's market was spurred by the emergence of cigarettes and smoking tobacco. W.T. Blackwell, who introduced Bull Durham smoking tobacco, hired Henry Reams to manage a small two-story building, converted into a warehouse, which held its first sale on May 18, 1871. The significance of this new house was that it marked the beginning of trade movement from Virginia into North Carolina. Opening day at Blackwell's saw both floors and the surrounding sidewalks filled with tobacco. Fifteen buyers showed up and purchased over 50,000 pounds of bright tobacco. Blackwell bought the first pile and a good portion of the rest. One historic note of this sale was that Mr. Dennis Tilley of Dutchville Township in Granville County brought in a load of extra-bright yellow tobacco, known as Dutchville Wrappers, which sold for $1.50 per pound. No doubt, Blackwell used the high price to his public relations and promotional advantage as he sought to inspire more farmers to bring their tobacco to Durham instead of taking it to faraway Richmond or Danville. In 1871, Durham sold about 700,000 pounds of tobacco and in 1872 that figure rose to over 2,000,000.

The Beginning: There Were Marketing Pains

Blackwell's success prompted others in Durham to enter the marketing business: Captain Edward J. Parrish, Blackwell's former auctioneer, also a Methodist preacher and barroom keeper, opened his house in 1873. Parrish sidelined his marketing trade with tobacco leaf dealership. Additionally, he solicited Northern buyers for whom he acted as buying agent. By 1887 his house was selling 8,330,000 pounds per season. His auctioneering talents served as added entertainment to townsfolk and farmers alike. Parrish was one of the most successful tobacco warehousemen of his time. In 1888 he built a new and larger house and advertised it as the "Best Warehouse, Best Light, and Best Accommodations, for man and beast in N.C. or Virginia. Stable holds 200 horses."

As part of an effort to shift the focus of attention away from Virginia, North Carolina formed its first association in 1887—the North Carolina Tobacco Association. Captain Parrish was instrumental in this and served on the committee to make sure the state and its tobacco growers (and no doubt, the warehouse) received the recognition they deserved in producing a finer quality of tobacco. Part of the problem faced by Tarheel producers was that Northern buyers had always assumed all tobacco advertised or purchased, whether from Virginia or North Carolina, was regarded as "Virginia" tobacco.

The *Daily Tobacco Plant* captured the scene of the market opening at Parrish's house as it described preparations: "The cloud of white canvas, or covers on Nissan wagons, poured into Durham from eight surrounding counties for the opening sale. Tobacco was placed on the new floor by Saturday in anticipation of the opening sale on Monday." J.J. Adcock, a prominent Granville county farmer led a cavalcade of his colleagues into the village amid shouts and a Methodist hymn. After the cavalcade, Parrish was presented a stylish fifty-dollar suit. Danville warehousemen responded with intensified efforts to lure farmers back to their fold. But the die was cast and North Carolina was permanently shifting tobacco production and marketing dominance into its boundaries. In 1908, Virginia boasted ten market towns and North Carolina had forty-five. In 1919, North Carolina had sixty-four and Virginia had twenty-three. Where production was concentrated, markets formed and warehouse numbers increased almost annually. By 1929, 83 percent of tobacco production was sold in one-third of the market towns; 35 percent of the crop was sold on five markets: Danville, Winston-Salem, Rocky Mount, Greenville and Wilson, with Danville being the only market outside of North Carolina with a decent share of sales.

The Danville System had not changed in concept since its beginning in 1858. Even markets with smaller volume supported numerous warehouses. Commerce in towns like Oxford, Clarksville, South Boston, Creedmoor, Youngsville and many others became more and more dependent on tobacco money for revenue generation. Almost all businesses founded in the smaller markets, as well as the larger ones, realized success or failure by the price farmers received for their crops. In practically all cases the price depended on demand for certain types and qualities within that type. A farmer had to school himself in producing a good crop. If he brought good ripe tobacco, cured just right and handled carefully, he could expect higher prices. If not, he would be disappointed. But equally so, the farmer had to know the system and know the nature of the buyers. It

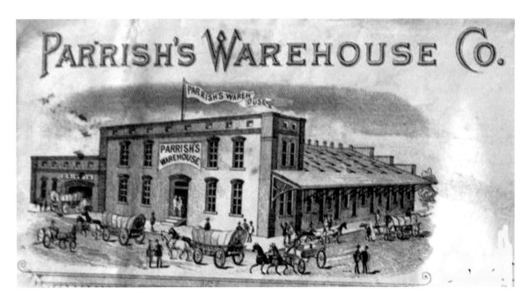

Post Civil War brought a flurry of tobacco marketing activity to Durham, North Carolina. Captain E.J. Parrish was one of the first to stake his claim on the trade. *Photo courtesy of Kristen Courie Wall of K.WALL DESIGN.*

was incumbent on the warehouseman, as agent, and the farmer as the principal, to work in close concert with the buyers to make a convincing case for all respective crops set out on the floor for presentation and sale. Many warehousemen often went to great expense in enhancing the farmer's production by distributing publications to farmers on the art of planting, cultivating, harvesting and curing, and of course, marketing. For the highest price, it was in the latter's best interest to always have the highest quality tobacco on his floor to attract the attention of buyers. This, of course, could be used in promoting the house's capability to get higher averages for his customers.

Tobacco production perimeters were widening constantly and farmers were literally spread out in all geographic corners that lay inside the practical reach of market towns. Thus, in some cases joint ownership was a good approach to the warehouse business. Joint owners usually lived in strategic locations around the market center and at least within comfortable traveling distance. Another arrangement involved the single proprietor who chose his crew or staff based, in part, on employee location within the perimeter or geographic proximity of the market. These owners and their representatives spent much of their off-season time "drumming" tobacco (soliciting trade for the warehouse). Numerous ploys were used in drumming tobacco, some ethical, some not, and some bordering on being illegal. This facet of the auction system wasn't the most effective one, however. Often drummers made promises to farmers that were impossible to keep, including higher prices and covert kickbacks, offers of free transportation to market, rebates on sales fees, commissions to those who brought in their neighbor's tobacco trade, promises to give extra enticement to buyers for a higher price on certain crops and loan advancements to those who had borrowed their limit at the bank. These and other characteristics earned them the general reputation as nuisances. Market associations,

The Beginning: There Were Marketing Pains

eventually formed in all markets, were chartered to monitor police and ultimately eliminate these tactics. In many cases, suits were filed against unscrupulous drummers. Boards of trade, as the associations came to be known, were called on to put an end to the drummer. In 1904 Pitt County farmers launched a premier effort to establish a "co-operative" marketing outlet, mainly to get rid of the drummer. Winston-Salem, through the Tobacco Board of Trade there, set up stringent regulations against the practice.

"First sales" were particularly attractive to farmers. A first sale meant that tobacco would be sold early in the morning and the farmer didn't have to hang around the better part of the day waiting for his tobacco to be sold. He could bring in his load the night before or early the same day, sell it and be home by dinnertime (noon). Some houses hung out the "FIRST SALE" sign, regardless of the time of sale. This lured the farmer in under false pretenses, but after the crop was unloaded and placed on the floor, it was too late and too much trouble to wade through all the long rows and reload it to be taken to another house. Under some conditions, farmers relinquished their crop to a speculator or "pinkhooker," who just happened to be close by and observe the situation. All in all, the farmers faced many stumbling blocks when they brought their year's investment to market. Yet a good warehouseman was conscientious and he understood the dependency he had on continued producer patronage. The stability of his business depended on this and he would always act in the true sense of the "agent."

The importance of the auction market to any town lay in its economic and social contributions. In the case of North Carolina belts, warehouse fees were established in 1898 at 2.5 percent of sale. Some of the warehouse checks were cashed in the town of sale and a proportionate share of the money was circulated among the local businesses. This increased out-of-town money flow into the community. It would be decades before the "hundred-mile" perimeter was to be put in place and farmers were at liberty to choose any warehouse they wished with no constraints placed on distance. The Oxford tobacco market, for instance, could solicit farmers from any tobacco-growing area. After production crept south into South Carolina, Georgia and Florida, the perimeter widened drastically. In many instances, banks sprang up in villages where the future of the local tobacco market seemed most assured. Not only banks, but also every firm in the market area had a stake in tobacco volume and price. The market's opening day brought out the best in town merchants. Street dances were staged, festive parades took place, sometimes beauty contest were held and retailers put on special sales. Big banners proclaiming "Welcome Farmers" were hoisted high. Everyone was the farmer's friend when markets opened. Opening day scenes included merchants courting the farmer heavily and premiering his latest wares. They filled their buggies with miracle goods, snake oils and such, and hawked them on the sidewalks and inside warehouses. In later days, when cars replaced the buggy, car trunk lids were raised, displaying large quantities of the same kind of items that had been around for years. Con artists mingled with the crowds, always looking for an easy mark among the farmers, whose pockets were lined with new tobacco money. There was a good reason for courting the farmer; his "gold" tobacco was now transformed into cash. Those who wanted their share of the action had to be on hand at the warehouse.

There has been little change in the process since 1858. The farmer harvested and cured his crop and brought it to a warehouse of his choice. He waited in line to have his crop unloaded, visited around with other farmers, neighbors, tobacco buyers and, in the earlier days, when there was no motorized transportation to get him home and back to the market before the next day's sale, he enjoyed whatever entertainment was available at local nightspots. Sometimes the warehouse provided entertainment. But when the sale started, the farmer was most attentive.

In earlier times, the start of the sale was signaled by a bugle. When the bugler sounded the opening, buyers gathered together across the tobacco row, opposite the warehouse representatives. In most cases the warehouse owner was the sales leader, who positioned himself first in line, then came the auctioneer and after him other house representatives, including the man who kept track of the price, pounds and the name of the buying firm. As overall production increased and congestion in the house increased, speed of sale became a necessity. It was incumbent on the auctioneer to keep a rapid pace and sell or "knock" a pile of tobacco to the buyer in a matter of a few seconds. On the other side of the equation, the buyer had the responsibility of quickly judging the value per pound. Of course, it was the sales leader's job to know within a few dollars what a particular pile of tobacco would bring. Since the inception of the auction, the time required to sell one pile has decreased from the 1858 rate of one every fifteen to twenty seconds. If a pile of tobacco brought an unsatisfactory price, the farmer had the prerogative of tearing off an edge of the identification and poundage ticket, which was placed on the pile. That told the warehouseman he wouldn't let his tobacco go for the price marked on his ticket.

Since the beginning, the auction system has survived several periods of unrest among farmers. Even though generally accepted by all sectors, the system has occasionally been bitterly attacked. Collusion in prices, oppression of farmers, especially when the prices have been low, and favoritism of certain farmers are among some of the charges brought against the system. These enduring suspicions still surface today, even though over the years all sides have consented to a multitude of measures to ensure fairness. However, leaders in the growing sector, dealers, exporters and manufacturers alike, agree that the tobacco auction method of marketing is practical in its nature and process. From the farmer's standpoint, his commodity can be brought before a concentrated group of buying representative firms that need the product for wholesale and retail demand. It is sold to the highest bidder in an expedient and orderly fashion and the farmer is then paid within minutes. For the most part, the charge of collusion comes, as earlier stated, when prices are very low. When this happens, the buyer is an easy and convenient source to which an accusing finger can be pointed. The seller gives little consideration to the influence of worldwide supply and demand, quality of the crop, variation in grade offering on the floor or buyers' immediate needs. After the turn of the twentieth century, many efforts toward cooperative marketing efforts arose, mostly resulting from farmer complaints about the system. Any immediate success that might have been realized lasted only a short while. There are a handful of exceptions to this: Fuquay, North Carolina, hosts a cooperative market today. It is one of over three hundred warehouses in operation in the flue-cured belt.

From the buyer's standpoint, the auction system has historically served as a concentration of supply. The cost of "barn-door" buying proved to be prohibitive, especially when taken into account that the crop was inspected and then displayed in loose-leaf form. The organization, the assurance of variety and the ability to satisfy demand from one house to another at a rapid pace, for these and other reasons, the auction system has proven to be far superior to any other method of selling tobacco.

From the warehouseman's standpoint, it is a lucrative business that affords him the flexibility of acting as agent for the farmer during the selling season, plus, he could offer the additional service of other farm supply businesses, such as fertilizer, seed, chemical, crop insurance, et cetera. Often he is looked upon to assist farmers in getting additional tobacco pounds, which, of course, would be sold at his warehouse. The community's vested interest lies in the revenue generated by the auction sale. It is the source of tobacco dollar distribution among small businesses, large corporations and private operators. To all affected, the system has proven itself over the past 130 years to be more acceptable than any method preceding it or any amended method introduced after 1858.

"The Duke Homestead"
by Linda Funk

"To tell the truth about it, twas an accident. I commenced to cure it and it commenced to git yallow. It kep' on yallowing' twell it got clar up...it looked so purty...and when it was cured it was musement for folks to come and see it."
—Stephen (a slave on the Abisha farm in Caswell County, North Carolina)

For two and a half centuries, Virginia was the foundation of tobacco production and culture. The Tobacco Society was formulated and sustained there. But when Washington Duke arrived home from the Civil War and staked the prospects of his future on tobacco trade, that all changed. Shortly thereafter, North Carolina wrested the trading reins from Virginia. That has never changed.

During the colonial period, tobacco became the most valuable export commodity of the mid-Atlantic region—the crop was often used in lieu of currency. During the American Revolution, tobacco played a key role in the success of the colonists' drive to gain independence. It bought needed supplies in Europe and was used to pay war debts. Following the Revolution, cultivation of the leaf spread into new areas of the country, including parts of North Carolina, South Carolina and Georgia. Crop production shifted from Tidewater Virginia into the North Carolina Piedmont.

The predominant strain of tobacco under cultivation prior to the Civil War was a dark variety grown in rich soil. During the early 1800s, however, prompted by the demand of consumers for a more mild-flavored smoking tobacco, growers began searching for a new variety of tobacco. They experimented with a poorer soil, which produced a more colorful and finer textured leaf. Still, no farmer was able to devise a formula that consistently produced a yellow tobacco—until, in 1839, an accident by a slave named Stephen led to the disclosure of a standard method for producing "bright" leaf. As tradition has it, young Stephen was tending the fires in a curing barn on a rainy night. He fell asleep and discovered when he awoke that the neglected fires had nearly died out. His wood was damp, so the boy ran to a nearby blacksmith forge and returned with

First factory.

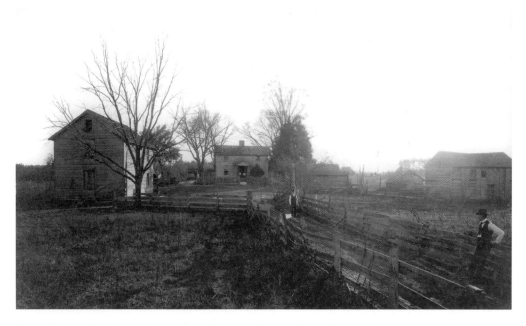

Second factory. *Both photographs courtesy of the Duke Homestead State Historic Site.*

"The Duke Homestead"

Tobacco ready to be auctioned at Northside Tobacco Warehouse, Smithfield, North Carolina, owned and operated by Edward and Faye Stephenson.

a supply of charcoal. The application of the charcoal on the embers of the fire resulted in a barnful of yellow tobacco. In 1856 Abisha Slade developed a systematic procedure for producing bright tobacco, implementing both cultivation of the crop on infertile soil and use of charcoal in curing. Slade's procedure claimed widespread attention among farmers along the Virginia–North Carolina border. Bright tobacco production increased gradually in the region until the disruptive effects of the Civil War temporarily brought its growth to a standstill; the new, mild tobacco was to have a tremendous impact upon the American tobacco industry.

WASHINGTON DUKE THE FARMER

The favorable publicity associated with the cultivation of bright tobacco stimulated Orange County farmers to begin growing it as a cash crop in the late 1850s. When his cotton crop failed, Washington Duke turned (in 1859) to the cultivation of tobacco, which he continued during the next few years until his farming operation was interrupted by the Civil War.

Washington Duke had left home around the time of his twenty-first birthday to take up tenant farming. The son of Taylor Duke, a farmer and respected neighborhood

leader who served as captain of the local militia and also as district deputy sheriff, Washington was the eighth of ten children. His basic education was gleaned from behind the handles of a plow in the rugged, rural setting into which he was born in the year 1820. As a young man, both his family and the Methodist faith would remain important to him. Years later, his son James B. Duke remarked: "My old daddy always said that if he amounted to anything in life it was due to the Methodist circuit riders who frequently visited his home and whose preaching and counsel brought out the best that was in him."

On August 9, 1842, Washington Duke married Mary Caroline Clinton. Two children, Sidney Taylor and Brodie Leonidas, were born to the couple, but in November 1847, Mary Caroline passed away. Left with two small sons to raise, Duke continued as a farmer, raising such crops as corn, wheat, oats and sweet potatoes. He had acquired his first land in 1847 from the estate of his father-in-law and had purchased additional property until he had accumulated over three hundred acres.

Washington turned his attention to providing a substantial home to shelter his family, and he completed the residence—now called Duke Homestead—in time for his marriage to Artelia Roney of Alamance County on December 9, 1852. The family soon increased from four to seven members with the births of Mary, Benjamin and James "Buck" Buchanan. Duke worked hard at farming, performing most of his duties without the benefit of slaves. Though records indicate that he owned only one slave, a female housekeeper, it is known that he participated in the common custom of hiring slave labor from larger farms and plantations.

Life was running smoothly for Washington Duke when, in 1858, misfortune struck again. His fourteen-year-old son Sidney became ill with typhoid fever; while trying to nurse the boy back to health, Artelia Duke also contracted the disease. Both she and Sidney died. Once again Duke faced the responsibility of raising his family alone. He managed with the aid of Artelia's sisters, Elizabeth and Anne, who volunteered to help run the household.

Washington Duke apparently joined the Confederate army in late 1863 or early 1864, though he was a Unionist who opposed secession and remained unsympathetic to the Confederacy. Because of a shortage of troops, the Confederate government enacted conscription laws that forced men to the age of forty-five to join the service. Thus, Washington was compelled to join the army and had to make arrangements for his family and farm before he entered the service. He sent his children to the Roney home in Alamance County, except for Brodie who accompanied him into service.

Duke decided to sell all his farm belongings and had converted all his means into tobacco by the end of 1863. It is not clear whether he sold or rented the homestead; however, he was to receive payment in leaf tobacco that was to be stored on the property.

During his brief military career, Duke was captured by Union forces and imprisoned in Richmond, Virginia. At the end of the war, the Federals released and shipped him to New Bern, North Carolina. Lacking money and transportation, the veteran walked back to his homestead—a distance of 135 miles.

"The Duke Homestead"

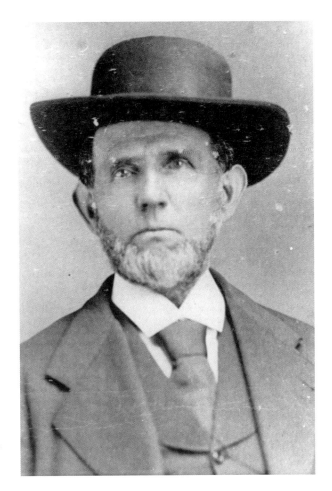

"I have made more furrows in Gods earth than any other man of forty years of age in North Carolina."
—Washington Duke.

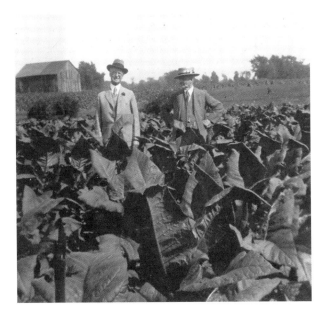

Washington Duke at his homestead. *Both photographs courtesy of the Duke Homestead State Historic Site.*

Cultivation of a Tobacco Empire

The trek back to Orange County marked the beginning of Washington Duke's rise to prominence in the tobacco business. He gathered his family and returned to his virtually barren homestead; having been unable to make the proper payments in tobacco during his absence, the tenants had been forced to abandon the farm to its rightful owners. Once again in full control of the property, Duke and his children began their smoking tobacco operation in a small log structure—now known as their first factory. Though a good part of Duke's stored leaf had apparently been confiscated by soldiers while he was away, his family members were able to fashion by crude hand processing the remaining portion into smoking tobacco, which they could trade readily for needed supplies and sometimes cash.

Washington took the manufactured leaf on a peddling trip into eastern North Carolina using a broken-down wagon and two blind mules to transport him. The trip was a success; merchants in small towns and villages were the best customers. Money realized from the sale of the tobacco was used to purchase family necessities such as lard and bacon—and a surprise bucket of sugar for the children.

The hamlet of Durham, a few miles from the Duke home, already had achieved recognition for its enjoyable smoking tobacco, a fact which may have contributed to Washington's initial success in peddling his product. As a result of the coming of the railroad in 1854 and a Southern shift in bright tobacco production, a few residents of Durham had begun manufacturing tobacco products prior to the Civil War. The first factory was opened in 1858 by Robert Morris and his son, who sold a brand called "Best Flavored Spanish Smoking Tobacco." During the proprietorship of John Ruffin Green, who bought the business a few years later, Durham emerged as a post–Civil War tobacco manufacturing center. Green, aware of the growing importance and popularity of smoking tobacco, was careful to produce a superior product, utilizing only the best grades of leaf available. By the close of the war, Green's pleasant-tasting tobacco had achieved fame; former soldiers, who had availed themselves of Green's stock of tobacco while encamped in the area, were sending requests from all over the United States for additional supplies of the brand. Green further popularized his product by adopting the bull as his trademark, an idea he borrowed from the celebrated English Colman's Mustard, whose label also bore the bull's head. In addition he renamed the brand "Genuine Durham Smoking Tobacco," which later would become known simply as "Bull Durham."

Following his profitable sales trip, Washington Duke began the manufacture of smoking tobacco on a part-time basis. Though farming tobacco, wheat, corn, oats and other subsistence crops took up much of the family's time, the Dukes were able to manufacture fifteen thousand pounds of their product, called "Pro Bono Publico," during the year 1866. This increase in production necessitated the utilization of other outbuildings on the farm, including an old stable—known as the second factory. Soon, in order to lessen the heavy workload and keep production up, Duke began buying additional tobacco from neighboring farmers.

"The Duke Homestead"

Though it was difficult to make a large profit on manufactured tobacco due to the high federal revenue tax placed on it during this period, the Duke country enterprise continued to grow steadily and subsequent peddling journeys were launched from the homestead. Prices for "Pro Bono Publico" increased but fluctuated over the next few years.

In 1868 Brodie Duke tried to persuade his father to move the manufacturing operation to Durham. Though Washington Duke decided to continue at the rural location, he provided funds for Brodie to establish his own factory in Durham, where he began production in 1870. Also around that time, Washington began to concentrate more heavily on the manufacture of tobacco; he constructed a two-story frame building—the third factory—and hired additional workers to handle the increased production. Still, the homestead tobacco business retained its simple, family-oriented manufacturing processes. By 1873, the Dukes were producing around 125,000 pounds of smoking tobacco annually.

As the enterprise steadily expanded, and the number of customers outside of North Carolina increased, Washington Duke began to consider the advantage of moving his business into town. Conditions in Durham in the early 1870s were very favorable for the manufacture of tobacco; the location of the North Carolina railroad station was convenient for shipping; and a warehouse for the sale of leaf tobacco had been opened in 1871. Durham was rapidly becoming a major tobacco center. In April 1854, Duke purchased two acres near the railroad where he built a new factory.

The shift to Durham, and the construction of the new factory there, marked the beginning of a large-scale tobacco company that climbed gradually to the top of the industry. At first, many of the basic hand methods used at the homestead were employed at the new factory. Washington Duke's sons took a more active role in the new factory and the family establishment. Brodie, who had gained experience and had become moderately successful as a manufacturer during his four years in town, moved his business into one wing of the new factory. Benjamin and Buck Duke were given equal partnerships and assumed much of the responsibility for company operations. Washington traveled throughout the country, concentrating his efforts on promotion of the company's products.

By now Washington Duke had established himself as one of the wealthiest men in Orange County and was fast emerging as a leading citizen of Durham. Affiliated with the Republican Party, Duke participated as a candidate in several local and state elections. Aside from his interest in politics, a much greater concern of Duke's was the stiff competition from other tobacco operations in the town. The old established leader was John R. Green's successor, W.T. Blackwell and Company, with its "Bull Durham" smoking tobacco, which became, for a time, the largest firm of its kind in the world.

The Dukes invited a new partner, George W. Watts of Baltimore, to join the firm in 1878 and renamed the business W. Duke, Sons and Company. The move was significant because Mr. Watt's investment broadened the company capital, enabling it to be more competitive with the older, more established firms. Although W. Duke, Sons and Company enjoyed a healthy trade in smoking tobacco, the keen rivalry with

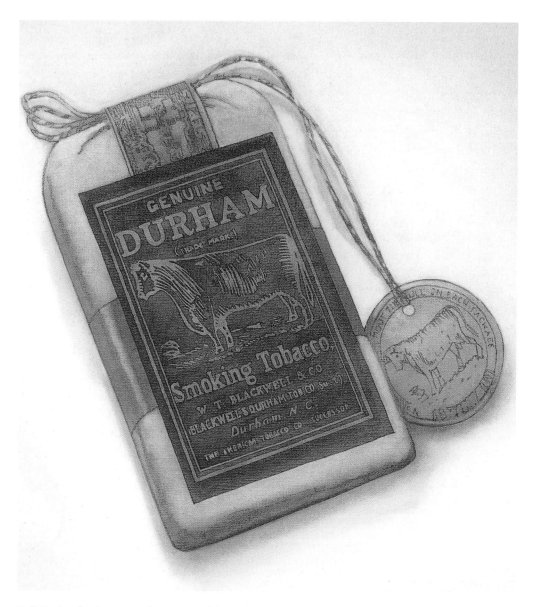

Bull Durham's tobacco pouch. *Courtesy of the Duke Homestead State Historic Site.*

W.T. Blackwell and Company finally prompted the Dukes to begin the manufacture of cigarettes in 1881. The practice of using cigarettes had spread from the European countries to the United States around 1860. The manufacture of cigarettes extended southward to Virginia and North Carolina in the 1870s and 1880s.

Early hand methods used in cigarette production were slow and tedious. An expert could roll only about four per minute. W. Duke, Sons and Company and other firms were forced to hire migrants from Eastern Europe who were skilled in cigarette making. As cigarettes grew in popularity, tobacco companies began the search for a mechanical

method of manufacturing them rapidly. Around 1877, the Allen and Ginter Company of Richmond, Virginia, offered $75,000 to any person who could invent a practical cigarette-making machine. Such a machine was developed in 1880 by eighteen-year-old James Bonsack; Allen and Ginter installed the machine in their factory, but discarded it as a failure after several trials.

In 1884, however, the Duke Company decided to take a chance on the imperfect Bonsack machine, leasing and installing two of the devices in the Durham factory. When working properly, the machine could perform the work of forty-eight hand rollers. When the Dukes encountered mechanical problems with the machine, the Bonsack Machine Company of Virginia sent a mechanic, William T. O'Brien, to Durham to refine the apparatus. O'Brien and Buck Duke were finally able to make the equipment work more smoothly, cutting the cost of cigarette manufacturing in half.

Believing that the new Bonsack machine eventually would eliminate hand processing of cigarettes, Buck Duke, in the spring of 1884, went to New York to establish a branch of the company there. This relieved the overburdened Durham factory and enabled the firm to gain a foothold in the national center of commerce and world trade.

W. Duke, Sons and Company was becoming the leading cigarette producer in the country. Increased advertising efforts enabled the firm to outsell its competitors. One journalist later noted that James B. Duke "was always an aggressive advertiser, devising new and startling methods which dismayed his competitors and was always willing to spend in advertising a proportion of his profits which seemed appalling to more conservative manufacturers."

By the mid-1800s Buck Duke felt that a merger of all large-scale tobacco manufacturers would be a practical way of reducing selling and advertising costs as well as improving overall organization. The four most important competitors of the Duke firm at that time were the Allen and Ginter Company of Richmond; the F.S. Kinney Company and the Goodwin Company, both of New York; and William S. Kimball and Company of Rochester—these and the Duke Company manufactured 90 percent of the nation's cigarettes in the 1880s. After discussing the merger, and following a period of excessive spending on advertising, the large rival firms agreed that the Duke firm's plan of merging was the most sensible proposal. In 1890, the five principal companies united to form the American Tobacco Company. This combination quickly became known as the "tobacco trust" because of its almost complete monopoly of the tobacco trade.

James B. Duke, in 1890, controlled the largest tobacco industry in the world; the combined firms continued to grow in the next two decades. However, by the turn of the century, antitrust sentiment was increasing rapidly in the United States. The prevailing feeling of the public that monopolies were harmful concentrations of power resulted in the dissolution of the American Tobacco Company by a ruling of the United States Supreme Court in 1911. Four major tobacco corporations were among those companies that emerged from the separation of the trust: a new American Tobacco Company, Leggett and Myers, P. Lorillard and R.J. Reynolds.

Following the court action, Buck Duke carried on his tobacco business abroad and invested money in the development of hydroelectric power. Later, Duke was to follow

in the footsteps of his father and brother Benjamin in distributing his fortune for the benefit of religious, educational and medical institutions. Washington and Benjamin had established a pattern of giving money to support the Methodist school (Trinity College) in Durham; James B. continued the tradition when, in 1924, the Duke Endowment was created for the benefit of his native region. In addition to the establishment of Duke University, formerly Trinity College, the multi-million-dollar indenture provided funds for educational institutions, orphanages, hospitals and the Methodist Church in the Carolinas. As a result of the family's generous gifts, millions of people throughout the region have enjoyed a better quality of life.

IMPRINTS AND FURROWS

The farmhouse at Duke Homestead, a plain vernacular house with hints of Greek Revival influence, was constructed in 1852 by Washington Duke. The two-story frame building originally contained only four rooms, two on either side of a central chimney. A small structure at the rear of the house served as a kitchen. It is thought that the kitchen may have been replaced later when the informal dining room was added; historical archaeology being carried on at the site will accurately determine the validity of this information. The interior walls of the home were fashioned of hand-dressed, heart-pine boards—a feature typical of North Carolina farmhouses of the mid-1800s. The furnishings and household items on display are representative of those that were in use in farmhouses of the region during the mid-nineteenth century. Beneath the house is a root cellar that served as a cool storage place during hot summer months for the family's stock of fruits, vegetables and other foods. A well house, smokehouse and grape arbors are near the house.

Tobacco, in its various stages of growth, can be seen at the homestead in the tobacco field where the crop is under cultivation. Agricultural information in the census of 1870 indicates that Duke raised a smaller amount of tobacco than neighboring growers. Tobacco cultivation around that time was a task that required long hours of work. During the winter months, the site of the plant bed was burned and cultivated. Burning was done to sterilize the soil and, in turn, decrease the probability of weeds and insects. Soon the bed was sown and covered with fine limbs of brush to protect the young seedlings from frost damage. Preparation of the tobacco field itself was also begun in winter. The soil was cleared of debris and fertilized. When the ground had dried just enough, the field was plowed several times, and a peg-booth harrow was used to further break the soil.

In May or June, during the rainy season, the seedlings were transplanted from the plant bed to the field. Workers first carefully drew the seedlings from the bed, laying each small plant at intervals in the fields; other laborers followed, using a peg to form a hole for the seedling, after which the peg was employed to cover the roots with earth. During the months that followed, the maturing plants required constant attention from the farmer. When it reached a height of two or three feet, each plant had to be "topped," a procedure in which the top portion of the plant was removed to control its

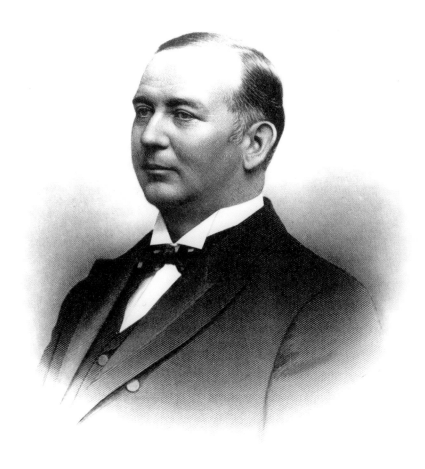

James "Buck" Duke. *Courtesy of the Duke Homestead State Historic Site.*

future growth, and so provide more nourishment for the remaining leaves. "Suckering" was the operation of removing new shoots or "suckers" that appeared at the base of the leaves after topping. If not removed, these growths would rob the developing leaves of nourishment. Several types of worms, including cutworms and hornworms, were a constant threat and, unless controlled, could quickly destroy the entire crop. "Worming" techniques included using turkey and guinea fowl to control the pests, or simply picking the worms from the tobacco by hand and destroying them.

North Carolina Tobacco

Curing barn. *Courtesy of the Duke Homestead State Historic Site.*

A nineteenth-century tobacco packinghouse, built with wooden pegs holding the structure together. It still stands on the Granville County homeplace of the author.

"The Duke Homestead"

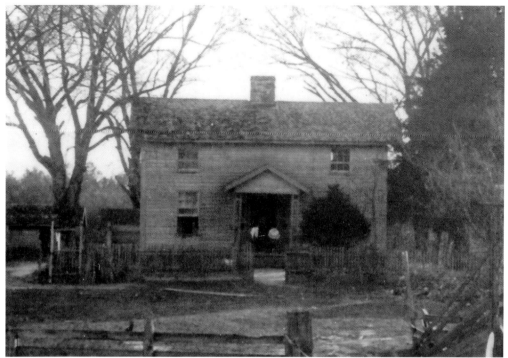

The Duke Homestead. *Courtesy of the Duke Homestead State Historic Site.*

The first "modern" tobacco factory built by the Dukes in Durham. *Courtesy of the Duke Homestead State Historic Site.*

Tobacco that managed to survive insects and disease usually was ready for harvesting by late August or early September. An experienced eye was required to determine the ripeness of individual plants; a ripened tobacco leaf appeared spotted and curled at the tip of the leaf.

During the early 1870s, farmers usually cut the entire tobacco plant, instead of removing the leaves separately. A small knife with a curved blade was used to split the stalk within three inches of its base; the entire plant was then severed below the split, inverted and placed on the ground between the rows until it could be gathered by other workers carrying tobacco sticks. The sticks, about four and a half feet long, held seven or eight stalks of tobacco. A nearby wagon carried the full sticks to the curing barn; the entire tobacco plant was cured, rather than single leaves, a practice that evolved and was in use later in the curing barn at the Duke farm.

Near the packinghouse stands the two-story frame structure known as the third factory, which was constructed around 1870 by Washington Duke to house his expanding manufacturing operation. Until that time, there had been no building on the property specifically used for the manufacture of smoking tobacco. The third factory was designed to receive and store unmanufactured tobacco and to house the manufacturing operation. The structure featured wide doors to facilitate loading and unloading of tobacco. Rafters inside the building held tier poles, probably used for hanging sticks of tobacco prior to manufacture; small doors in the attic were opened or closed to regulate the moisture content of the hanging leaves. Square holes cut into the ceiling of the first floor apparently were openings for chutes. The manufactory probably contained no sophisticated machinery; no records have been found detailing the interior contents, though it must have contained such items as flails, sieves, work tables, weighing scales and an assortment of baskets and barrels.

The process of manufacture at the third factory was simple and slow—as it had been at the first and second factories in use previously. Workers flailed the cured tobacco, beating the dry leaves into a very fine state; by forcing it through a sieve, laborers then granulated the crushed leaf; other skilled workers weighed and packed the sieved tobacco. Demonstrations of processes used in early tobacco manufacturing are presented in this factory.

Note: This extract is from *The Duke Homestead Guidebook*, written by Linda Funk with historical research provided by James R. McPherson and Stephen E. Massengill. Published by the North Carolina Division of Archives & History, 1978. Reprinted with permission.

The Tobacco Auctioneer

Various facets of the auctioneer's unique history have been presented. His ritualistic chant has been traced by some back to the Catholic Church's medieval Gregorian chant. Others believe it was simply an amalgamation of an African slave chant with an added staccato/rhythmic flair. For the most part, neither theory can be presented as fact. Historical documents trace the roots of the independent auctioneer to a gentleman named H.B. Montague of Henderson, North Carolina, then a part of Granville County. In response to growing unrest stemming from the woes and suspicions of the seventeenth- and eighteenth-century antiquated marketing inspection system and government-paid "inspector/criers," Montague advertised himself in the *Richmond Enquirer* in November 1827 as an "Independent Tobacco Auctioneer, one of integrity," thus setting the stage for the commercial auctioneer, and pioneering the credentials for those who came after him.

The entertaining chant and antics of the auctioneer in 1898 were born just after the Civil War. They were the first-generation product of Chiswell Dabney Langhorne. Langhorne, a jovial and light-hearted prankster, was born in 1843 in Lynchburg, Virginia. "Chillie," as his parents called him, and "Dab," as he was referred to by his wife, was a maternal cousin (on the Dabney side) of Confederate General "Jeb" Stuart. Some also claim he was a distant relative to Mark Twain (Samuel Langhorne Clemens). At any rate, he was a handsome and stately man of medium build, with blue eyes, slightly drooping eyelids, light brown hair and a thick, short handlebar mustache. At age nineteen he had joined the cause of the Confederacy, initially as a member of the Eleventh Virginia Infantry under the commands of Generals James Longstreet, James L. Kemper and Ambrose Powell Hill. While en route to Gettysburg on June 30, 1863, he was stricken with high fever and boils and was returned home to recuperate, then to reenter the war for the duration.

After Lee surrendered to Grant in April 1865, Langhorne settled in Danville. With his wife, mother, three sisters, one brother and disabled father, Chillie joined forces with

North Carolina Tobacco

In October 2003, two legendary tobacco auctioneers posed together in the old House chambers in the North Carolina State Capitol after ceremonies inducting L.A. "Speed" Riggs into the North Carolina Agriculture Hall of Fame. *Left to right*: Sherwood Stewart and Jimmie Jolliff.

his fellow countrymen to face the arduous postwar task of reconstruction. He rounded up a few old, rundown horses, opened a livery stable and tried his hand at supplying the horsepower for Danville's rebuilding effort. This, however, met with limited success, and Langhorne soon lost interest. For supplementary income, he worked as a night clerk in a local hotel and launched a potentially promising career in the boarding business. Being of a fun-loving and entertaining nature, however, Langhorne was easily bored with clerical chores. At best, the work of a night clerk, especially after midnight, was quite boring. Unfortunately for Langhorne, he could not handle the quiet stillness of the wee morning hours and, craving a bit of excitement, he dashed over to the fire bell and rang it loud and long. Then, as the clientele dashed wildly through the lobby, escaping what they thought was a fire, Langhorne thoroughly doused them with the hotel water hose. Needless to say, the hotel owner and his patrons failed to see the humor. Daylight found Langhorne back on the street looking for work.

Two different and credible sources—Jimmy Morgan, another relative of Langhorne and a retired auctioneer of Sanford, North Carolina, and legendary U.S. Senator Sam Irwin—tell similar stories of how Langhorne came to formulate the basic pattern and delivery of the auctioneer as it sounded at the opening of the Smithfield market, and as it exists today. After the ordeals with the livery stable and the hotel, Langhorne went to Richmond, and while visiting with a friend one Sunday morning, he attended local Catholic services and listened as the priest chanted his usual rituals and prayers. He desperately needed income to support his family in Danville, and he knew tobacco was the basic commodity sold there. Wanting to find a niche in the industry, he reasoned that maybe he could supply the entertainment needs of warehousemen back home by emulating the priest's stimulating chant, along with what he later coined, a "pitter-patter" and "gobble gook" that would stimulate the buyers and be pleasing to the gathering public. Based on what he heard in Richmond, Langhorne created a unique and rhythmic chant and body language to match. He carved his new invention into a lively and musical sales gimmick and set about vending his strong voice and talents to solicit bids from the buyers at the sale.

His charm, both in and outside the warehouses, was magnetic. Soon the word spread and wherever "Chillie" Langhorne sold tobacco, the crowds would listen in amazement. Tobacco manufacturers and processors in Richmond heard about Chillie and offered him a job there. After arriving in Richmond, a local businessman offered him the opportunity to invest in building a tobacco company. He wasn't interested, however, and left the formation of the company to his friend and other investors. Today, the company is known as British American Tobacco Company (BAT).

Like his tenure in the livery stable and other businesses, Langhorne soon lost interest in tobacco and eventually took an opportunity offered him by an old Confederate friend, General Kyd Douglas, to help build railroads. Finally, he moved permanently one hundred miles northeast to Bremo, Virginia, where he fathered the last of his five boys and girls while becoming wealthy in the railroad business. He died on Valentine's Day, 1919. His legacy was the beginning of a new and enduring chanting method of tobacco sales. Many of his successors in the profession tried in vain to match his antics and voice,

but none could. Old Belt auctioneers like Garland Webb of Durham, Frank Barfield, Captains E.J. Parrish and Ed Pace were greatly influenced by Langhorne, but could only make a feeble effort to emulate his talent. Some, who couldn't create the sound, compensated by fancy dress, with high top hats, silk blouses and gold knob walking canes, which they would swing back and forth across the tobacco rows in gestures to urge bids from the buyers. T.S. Ragsdale and H.L. Skinner, both of whom were a part of the Smithfield opening of 1898, were no exceptions. Langhorne's influence was quite prominent in their demeanor.

It was not until February 1938 that Chillie was replaced as the standard bearer and mentor for all tobacco auctioneers. His successor was Aubrey Riggs. In 1937 George Washington Hill, president and advertising genius of American Tobacco Company, was agonizing over developing an aggressive promotional tool to bolster the market position of his most promising brand, Lucky Strike cigarettes. The traditional methods of coupons, collectable cards, et cetera, had become mundane, not just with American Tobacco Company, but with competing brands as well. Hill needed something different. He had heard American Tobacco's leaf people and buyers talk about a tall, lanky auctioneer, with big ears and a protruding Adam's apple, selling in Durham, North Carolina. His chant was exciting and different from those heard before. In November, Hill chartered a private train, gathered up his entourage and traveled, unannounced, to Liberty Tobacco Warehouse on Rigsbee Avenue in Durham. What he heard there was about to change the entire concept of cigarette advertising. There he heard Aubrey Riggs, as his family called him, or "Speed," a nickname his rapid-fire chant had earned him. During a break in the sale, Hill invited Riggs into the office of Mr. Frank Satterfield, the manager and sales leader. As Riggs recalled forty years later, the conversation was short and to the point. "Young man," said Hill to Riggs, "I like what you got. How'd you like to go to New York with me and be on radio?" "Well, I dunno," said Riggs. "I'm on contract here to Mr. Satterfield and don't see how I can get away right now." "That's not a problem," said Hill, "I've already spoken to Mr. Satterfield and he is willing to make other arrangements for the rest of the season." Whatever the concluding results of the conversation were, Riggs didn't go to New York right away. Instead he went in late December.

In most all physical, social and material respects, Riggs was the exact opposite of "Chillie" Langhorne. Riggs was born of ordinary means; Langhorne's family was wealthy. Langhorne was by nature a clown and prankster; Riggs had a natural knack for entertainment, but was very serious minded. Riggs was born on February 18, 1907, in Silverdale, a small rural community in Onslow County, North Carolina. His father, Mark, moved the family to Goldsboro in 1921, planted a small patch of tobacco and established a truck farming business. Each year Mark and Aubrey sold part of the family's seasonal harvest a few miles south at the Faison Produce Auction. The unique and festive atmosphere of the auction fascinated Aubrey. He was especially drawn to the antics and seemingly complicated chant of the auctioneer as he strutted up and down the narrow rows of fruit and vegetable baskets, gesturing to the collection of buyers as they followed along. The novelty of it all was thrilling and challenging. The chants

continued ringing in his ears, even after the sale was over. Soon he developed his own singsong chant, using a staccato and fast-pace rhythm, all accompanied by the works and tune of "Yankee Doodle." He once told me:

> *I would walk up and down fences and sell the fence posts. I would sell mailboxes and trees as we rode by. Sometimes my daddy would threaten me with a beating to get me to stop "that bunch of noise" I was making. But I wouldn't stop. I'd just get out of earshot and keep going. Sometimes when I'd get into bed at night, I'd put my head under the cover and hum a chant. Nothing in my life, before or since, captivated me any more than an auctioneer's chant. I knew one day somebody was going to hire me to sell produce for them.*

At eighteen years of age, Aubrey realized his calling and worked almost obsessively to perfect his own signature chant. Like too many other teenagers of his era, he had already quit school to help the family make a living. By his early twenties he had begged his way into selling a row or two of produce at the Faison market. But then something else stirred his passion even more strongly as an aspiring auctioneer. A tobacco sale! He went with his father to sell their tobacco crop at the warehouse along Williams Street in Goldsboro. And, far more than with the produce auctioneer, he was captivated by the

"Speed" Riggs speaking to a gathering crowd at the October 1986 Mock Tobacco Auction, held at the Duke Homestead State Historic Site, Durham, North Carolina.

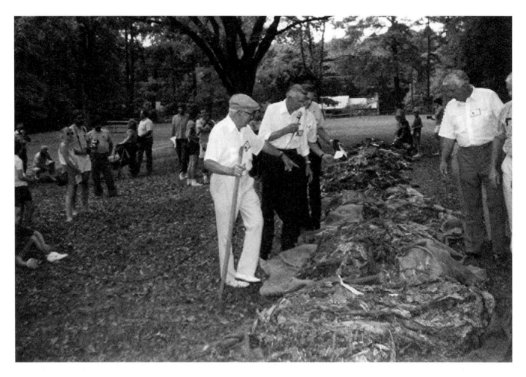

An October 1986 photo of "Speed" Riggs, taken at the Duke Homestead's annual Mock Tobacco Auction, as he delivered his world famous "SOLD AMERICAN" tobacco auctioneer's chant for the last time. The man leading the sale is W. W. Yeargin Sr.

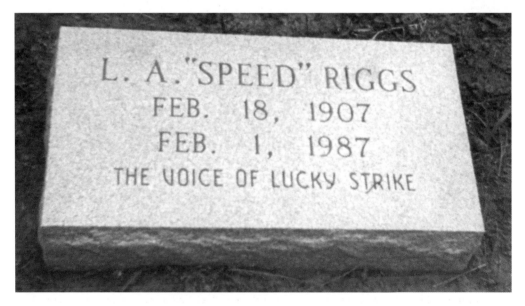

A granite stone commemorating the life of L.A. "Speed" Riggs. This stone is situated at the foot of the grave of Speed's father, Mark Riggs, in a cemetery in Goldsboro, North Carolina. At the request of Speed, his remains were cremated and I spread them over the spot of the annual Mock Tobacco Auction, held annually at the Duke Homestead State Historic Site.

The Tobacco Auctioneer

Legendary tobacco auctioneer L.A. "Speed" Riggs was to the tobacco auctioneer what Frank Sinatra was to other singers. He set the pace, style and degree of color for all tobacco auctioneers after him. His rapid-fire and singsong chant was mimicked by more tobacco auctioneers than any other living individual in the marketing industry. Here, in September 1981, Harry Crisp, from Pinetops, North Carolina, an auctioneer for Farmers Tobacco Warehouse in Greenville, North Carolina, tells how he has idolized Speed's way of auctioning tobacco since he was "knee high."

Left to right: Harry Crisp, Harold Watson, Billy Yeargin and "Speed" Riggs.

spellbinding chants ringing out over the rows of sweet-smelling tobacco. Much to his liking and developing style, the pace of the chant, as well as the sale itself moved faster, which better suited the high-energy young man. Just as he had done in Faison, Aubrey begged his way into selling a row or two here and there. By his mid-twenties, he became a professional tobacco auctioneer. He could now put to use those ten years of honing to perfection his rapid-fire, rhythmic and galloping chant. Like Langhorne's chant of sixty years earlier, crowds loved it, and it was to become the envy of all auctioneers. He soon earned the nickname "Speed" and at thirty years of age was a full-fledged tobacco auctioneer.

As a result of the November meeting between Hill and Riggs, radio sound waves soon beamed the voice of L.A. "Speed" Riggs from the Atlantic to the Pacific Ocean. On December 28, 1937, Speed made a guest appearance on the nationally broadcast radio show called *Your Lucky Strike Hit Parade* and demonstrated his unique tobacco auctioneer's chant. His appearance marked the first time the tobacco auctioneer's chant had ever been heard west of the Mississippi River. As Riggs stood before the NBC microphone in New York, shaking in his boots and preparing to belt out his best galloping chant, Hill instructed him to tag it with three words: "SOLD TO AMERICAN." Thus was born a new concept using electronic media for cigarette sales.

Public response was so great that in February of 1938 Speed was named "the Voice of Lucky Strike." In a three-year period, from 1938 to 1941, this new commercial,

combined with American Tobacco's popular radio show, *Your Lucky Strike Hit Parade*, catapulted Lucky Strike cigarettes ahead of all other brands by a three to one margin. At once Speed became the enduring role model for all auctioneers. His international ambassadorship as "The Voice" for the American tobacco industry reigned for thirty-three years, until Congress outlawed electronic media cigarette advertising effective in 1970. This forced American Tobacco to cancel both the *Hit Parade* and Speed's contract. His presence had become so prominent among the public in general, and tobacconists in particular, that, even though he died at 4:31 a.m., Sunday, February 1, 1987, his voice, name and face (or all three) remain recognized by those who came along during his career.

Even today, when an auctioneer hams it up and throws a bit of stylish entertainment into his chant, quite likely he is mimicking Speed; in many cases, without even realizing who originated the style.

In the mid-nineteenth century, "Chillie" Langhorne formulated the modern day esoteric and rhythmic chant of the tobacco auctioneer. "L.A. 'Speed' Riggs of Goldsboro, North Carolina," as he was introduced internationally for over thirty years, perfected Langhorne's style and imagery, and then added his own "singsong" signature chant. He became the twentieth-century "Granddaddy" of them all.

A Story of the Tobacco Market Opening in Smithfield, North Carolina

By 1898, the cogs of the Tarheel flue-cured-tobacco marketing wheel were gradually drifting eastward, including the experience and expertise of veteran warehouse staff and buyers. In Smithfield, situated in what came to be known as an Eastern Belt market town, there came Hugh Landis Skinner, former sales leader from Oxford, and his brother-in-law Nathaniel M. Lawrence, a bookkeeper, along with a Captain Barham from Wilson. Others, serving more or less as advisors and onlookers, came from the Old Belt markets along the North Carolina–Virginia border, such as Lynchburg, Richmond and Petersburg. The manufacturing firm of Long and Hubbard, with ties to Person County and other markets in the Old Belt, sent a buyer—E.L. Bryan, a leaf dealer from Durham who came with orders. George Hubbard of American Tobacco Company and J.T. Hart of J.P. Taylor also joined the entourage of buyers. Hogsheads, needed for packing or prizing tobacco for shipment, were to be manufactured by the livery firm of Lemay and Ellington, whose skilled staff of able-bodied coopers stood ready to turn out several each day.

The first load of tobacco was delivered to Banner Warehouse on Wednesday, July 27, by Dr. W.E. (Willis Edgar) Turlington, a forty-two-year-old farmer and surgeon from Benson. He was the son of Eli and Sarah Turlington and a graduate of Baltimore Physicians and Surgeons. No doubt, as it made its way through the streets, the excited crowds gathered to assess the quality and to speculate on the price it might bring on opening sale. Anticipating the historic nature of the event, Dr. Turlington must have embraced each golden leaf with warmth and attention—striking, caressing and pressing it out for appearance.

Finally the market opened to a jubilant reception by farmers and townspeople alike. Fifty thousand pounds were sold at an average of $8.00 per hundred, yielding a total of $4,000.00 for the first day's sale. Banner's proprietors, Barham and Skinner, were suddenly larger than life in Smithfield. And just as suddenly, the farmers of Johnston County felt a new sense of worth. They were publicly congratulated for rising to the

challenge and producing a crop of tobacco equal to those in the fields north and west of this coastal plains community. On Friday, July 29, the *Smithfield Herald* proclaimed, "A new era is dawning for the people," and printed a bracketed advertisement boasting of the advantages already claimed by the tobacco market:

> *TWO LARGE SALES WAREHOUSES are opened by competent and clever gentlemen. Both houses are well lighted and fitted with appliances for the quick and accurate transacting of business.*
>
> *THE BANNER AND THE RIVERSIDE*
> *The proprietors of the first are Messrs. Barham and Skinner, the second, Messrs. Thomas and Ragsdale. These Gentlemen will protect the farmer. They will see to it that your Tobacco brings its worth.*

On August 5, 1898, along with the public report on the Democratic Convention, came the announcement of the second warehouse opening. The Riverside would open six days later on August 11. On the same day, the county's faith in its future partnership with tobacco was reaffirmed by the announcement that, within two weeks after the Banner's opening, the siblings of Johnston's new industry would establish a Tobacco Board of Trade. This would take place at the opening of the second warehouse.

The *Herald* played a leadership role in bringing the market to life in the North Carolina town. As the announcement of the board of trade was made, the *Herald*, justifiably taking on the air of a proud parent, touted its role in the new events:

> *THE PROSPECT IS BRIGHT*
>
> *No one is more gratified at the successful opening of our Tobacco Market than is the Editor of the* Herald.
>
> *Several months ago we urged that here was the logical location for a market, and attempted to impress upon the citizens of our town the necessity of preparing to handle the crop, in the cultivation of which we see a bright future for our section. We kept hammering about it until a start was made, and since then we have been blowing not a little of the advantages our town possesses as a tobacco market.*
>
> *We go down justified. The opening break exceeded out highest expectations. We were sanguine but not to such an extent as the success of the opening would justify. Everybody was surprised. Tobacco men remarked that they had never seen a similar instance on an older market.*
>
> *Smithfield, with but one of her warehouses open, sold on her opening day ⅔ as much tobacco as did Wilson on her opening day with 4 warehouses open.*
>
> *Farmers from every section of the county have sold their crop here this season and satisfaction is simply universal. High prices have prevailed; the tobacco buyers and warehousemen are accommodating, and all pleased with the prospect of selling the crop at home. The farmers are favorably impressed with the tobacconists, the tobacco men are*

A Story of the Tobacco Market Opening in Smithfield, North Carolina

immensely pleased with the fine conditions existing here favoring a great market, and all are satisfied.

If the prices rule as high as the opening sale would promise, an enormous quantity of tobacco will be sold here this season. If this year's crop is a success and we see reason why it should not be, next year Smithfield will become one of the largest markets in the state.

The *Herald* was prophetic. With the opening of Riverside only two weeks later, the market increased 100 percent, from the fifty thousand pounds it sold opening day, to one hundred thousand pounds. Word of Smithfield's credibility quickly spread to prospective buying firms, such as Liggett Myers, Imperial and Lorillard, who had taken a "wait and see" attitude. R.J. Reynolds at the time was only interested in plug tobacco grades. Manufacturers and processors from miles around sent leaf experts to scout out the value and potential of the market.

As the Riverside approached its opening, the owners and operators circulated a public information flyer listing the competent force that was assembled to represent the farmers and please the buyers. They were Thomas S. Ragsdale, a sales leader from South Boston, Virginia, in the heart of the Old Belt; a Mr. Betts, assistant sales leader; P.T. Beasley, a bookkeeper and Johnston native from the quiet and still scarred Civil War community of Bentonville; and Edward Jones "E.J."Ragsdale, auctioneer for Thomas and Ragsdale. The Ragsdales, natives of Franklin County, had been one of the driving forces in bringing tobacco to Johnston County and were settling in with their families here. As a full-time sideline, the elder E.J. Ragsdale had taken on the management of the Central Hotel, which he labeled the "Only Second Class Hotel in The State." His rates were $1.50 per day and his advertised slogan, "OURS TO PLEASE," invited his guests to "come again, if not, pay your bill and hit another place."

The excitement and anticipation of prosperity had been well founded. The market had met and surpassed the expectations of even the most optimistic. Before the doors closed on the first season, over 1,000,000 pounds of tobacco were sold, at an average of $9.00 per hundred, $3.00 per hundred above present cotton prices. This performance was unmatched by any other. It was a record for North Carolina tobacco markets. Original records of sales, now enshrined in the Johnston County Room of the Smithfield Library, show prices ranging from a low of $1.80 to a high of over $10.00 per hundred. On September 23, H.M. Johnson sold 1,050 pounds for a total of $37.64. Most of it was bought by E.L. Bryan of Durham. C.P. Jones sold 454 pounds for a total of $17.38 and "Shern-Lawter" (Nathaniel Macon Shearin and Robert Anderson Laughter) sold 662 pounds for $25.99.

In effect, this was a giant shot of economic adrenalin. It opened the door of progress on many levels. The market success spawned greater industrial faith in the future. Testimonies to this included the announcement by Mr. J.H. Kirkman, insurance man and owner of the local Telephone Exchange, that the phone systems between Smithfield and Selma were now being connected. Additionally, there would soon be connections with many other significant locations, including Raleigh, Durham, Wilson, Goldsboro, Fayetteville, Rocky Mount and Tarboro. In January 1899 Kirkman sold his thriving

general merchandise business to devote all his time to the communication business. Mr. W.T. Adams, closely tied to the new Bank of Smithfield, turned his grocery business over to Messrs. John and Louis Ennis in order to fuel the growth of his new brokerage business. More and more the sleepy town on the Neuse was awakening to a new and promising future. The county's premarket excitement was nothing short of exuberant. But from a retrospective view, the success of the first season only whetted the yen to hasten the second. The proof was in the puddin'.

Changes and preparations began for 1899 almost as soon as the doors closed on 1898. The dawning of '99 revealed changes in management and ownership. January 6 brought the news that Captain Barham was retiring from Banner, and Skinner and Ragsdale would combine their talents and experience to carry on. The new force would include Oxford native Lonnie G. Patterson as auctioneer, L.C. Morris as canvasser and the continued services of Skinner's brother-in-law, Mr. Nathaniel M. Lawrence as bookkeeper. In preparation for the second season at Riverside, the facilities had been expanded by thirty feet and additional lights were added. Mr. Charles B. Taylor, a well-known tobacconist and respected auctioneer of Goldsboro, would join the team of W.R. Long and W.M. Ives as operators there. Everyone was now caught up in the impending economic boom. Farmers scrambled to gather production knowledge so they might be prepared to share the wealth. With encouragement from county leadership, determination and instructive articles by Beatty of the *Herald*, plans were made to supply the 1899 season with four million pounds of tobacco. Others adopted an "I told you so" attitude. The lead item in the *Herald*'s popular "Local Notes" column on Friday, January 20 was: "Get some tobacco seed." The second item was: "Plant several acres in tobacco." The third: "Sell your crop on the Smithfield market."

In the adjoining column was the declaration:

MONEY IN TOBACCO

There is money in raising tobacco when proper attention is given to the cultivation and curing of the crop. Messrs. Joe and Alex Johnson, of near Smithfield, who have raised tobacco two years obtained the following and vary gratifying result last year, their second season:

Cost of cultivation and Curing four acres tobacco,	--- $100.00
Sales of tobacco amounted to	--- $632.19
Profits,	--- $523.19

What these men did others can do.

The folks over in the Polenta community sent word to Smithfield that, for the first time, several farmers there would have a crop ready when the market opened next summer. Said one, "This betokens better times for the community. It is a risky business to depend on five cent cotton." On January 27, Thomas Ragsdale publicly submitted details on

planning and preparing the seedbed, including the importance of selecting a sheltered and drained site in "original forest, if possible, and select a place near a branch or stream of water, embracing both hillside and flat." On that same day, the *Herald* reported the 1898 cotton crop at 11,200,000 bales, noting that few farmers in Johnston County made money on cotton during the '98 season, and predicting a decrease in acreage for 1899. Then a week later, as if to provide regular educational continuity to the prospective but inexperienced and ill-equipped farmers, the *Herald* offered instructions on the unique construction of tobacco curing barns:

TOBACCO BARNS IN JOHNSTON COUNTY

People differ as to the size to build barns. Sixteen or eighteen feet square are good sizes. A barn 16 x 18 feet is a favorite size with many. Barns can be built with logs or planks. If planks are used they should be doubled. If logs are used, select as straight as possible, from six to eight inches in diameter. It will take from eighty to eighty-four logs to make a barn the proper height. Cover with boards or shingles; of course, shingles make the best cover, but board roofs will cure the best in warm weather. Most farmers prefer board roofs as giving best results. Chink the cracks thoroughly with wood and mortar. It is best to use lime mixed with clay, as it will save the expense of dobbing over every year. Make the barn as nearly air-tight as possible. Put the first set of tiers about seven feet from the ground. If the logs are large, put in tiers for every three logs; if small, skip four; nail on to the rafters until you reach the top. Put door in south side, if possible. You may put a window in both or one of the gable ends. If you use a double furnace, put arches on one end; make them of brick. Extend arches out eight feet inside, one or two feet on the outside. Twelve-inch piping is as good a size as you can use. If you use a single furnace put one in the center of one end of the barn, and let the brick work extend to within a foot and a half of the other wall.

In February, R.A. Laughter, an experienced grower west of town (on present-day Highway 210), published an abbreviated yet valuable message on breaking land and cultivation. Laughter's credentials were impressive. He was a native of Halifax County, on the eastern edge of the Old Belt, where tobacco had been produced for more than two centuries. His message, entitled "A Tobacco Letter," was published on February 27, 1899, and read as follows:

Soil for tobacco should be well broken with turning plow and where it was broken early in the year it should be broken again to get it thoroughly pulverized. Where stable lot manure is to be used, it will pay the tobacco planter to lay off his rows and put out his manure as early as possible and cover with plow or harrow. Reopen the rows about the middle of April and put no fertilizer.

From six to eight hundred pounds per acre I think will give the best results in Johnston County. Cover with turning plow and use a common drag to work off tops of beds. Then make hills about three feet apart by clapping with a hoe or shovel, having first removed

any clods or litter that may be in the hill. Your soil is then ready for setting the plant. To make a good crop of tobacco, the plants should be set out as early after April 20 as plants and seasons will permit and not later than May 20.

The regularity of news and publicity promoting production—including extensive and numerous articles by Thomas Ragsdale and other seasoned "experts," addressing each step in the process from seedbed to warehouse floor—shows the degree of excitement and promise tobacco was bringing to Johnston County. Amid some of the local reports of new business being generated by the optimism was a new farm publication, the *Southern Cotton, Grain and Tobacco Reporter Journal* of Asheboro, which was available to spread Smithfield's agricultural gospel in March.

Perhaps, even the thirst for unruly entertainment had subsided to a controllable degree. The crowd during court week was unusually docile as the mid-March session commenced. "Only a few drunks being offensive," reported the *Herald*.

Well into the twentieth century, old tobacco barns still stand alone, with one single purpose: to remind passersby of the centuries of hard labor, togetherness and joyous laughter of little children and old folks—all sharing a common bond—which tobacco farming brought to the area.

A Story of the Tobacco Market Opening in Smithfield, North Carolina

All during the winter months, as farmers pondered crop decisions for the year, they were bombarded by instructions on the different phases of tobacco cultivation. Short messages appeared constantly in the "Local Notes," asking, "How many acres of tobacco will you plant this year?" and declaring, "From the amount of tobacco seed given out at this office it seems that all of Eastern Carolina is going into tobacco season" and, "The tobacco farmers of the county are the only ones who made any money last year. And they will be the only ones who will make it again this year." Merchants, realizing the imminence of the impending tobacco explosion, added a new dimension of supplies to their stock. S.B. Johnson advertised his "car load of tobacco flue iron bought for spot cash before the advance in price on iron." E.L. Hall of Hall's Hardware House in Benson, who had boasted of his tremendous array of farm supplies, including Boy Dixie, Clipper, No.2 and Ward Turn Plows, Hames, Traces, Collars, et cetera, now focused more on his ability to manufacture flues right on the spot. With raised and prominent newspaper lettering, he advertised, "TOBACCO FLUES 'TO BEAT THE BAND,'" and then he exhorted the talents of MR. J.D. Bain, his business associate, who, he said, was "one of the best in the state." Mr. W.M. Sanders, who alone sold 315 tons of tobacco fertilizer for the season, invited his friends to "call and get my prices" on plant bed covers. He also warned farmers to "look out for worms" and promoted his Paris Green and Land Plaster as a fine mixture to destroy them.

Being properly equipped and prepared with tobacco sticks was essential to curing. Captain Edward Pace, who nine years earlier had encouraged and instructed farmers on the intricate steps of the process, issued another lesson on tobacco sticks. He reminded farmers that tobacco sticks were an essential element in housing the crop. "One thing, you can't cure your crop unless you have sticks," he said. And he cautioned:

> *Now is the time to get them out before you get busy, and let them be thoroughly seasoned. For every four acres of tobacco, rive out and have sawed 5,000 sticks. Four feet, six inches long, three fourths to an inch thick, better have a few more than not enough. Here's the comparison: If no plants, no crop; if no sticks, no curing sure, and this is as true as preaching and good preaching at that. Your tobacco, when cured must remain on the sticks, it's the only safe way to handle it and save your crop.*

Under the spacing rule for curing tobacco in 1898, a sixteen- by sixteen-foot barn would hold four hundred sticks. And, of course, a ready-made supply of tobacco sticks was already available. Smithfield merchants J.D. and E.F. Boyett were selling tobacco sticks made and patented by J.B. Paschal of Wilson for $2.25 per hundred. As winter became spring and planting began, word of the progress steadily filtered into town. In early May, Mr. D.L. Flowers reportedly brought in the finest plants seen so far. And the news from the Polenta community was that cotton acreage would be down from last year, and if the tobacco crop could bring a good price in 1899, several additional farmers would join the ground swell of production the next year. The rate of traffic in flues, sticks and other tobacco staples gave the assurance of a tremendous crop for the market opening.

A few incidental notes of the day included news that Mr. Nathan Tart had been thrown by his runaway mule and suffered, among other injuries, a dislocated shoulder. Mr. N.W. Porter had met the same fate with his shoulder from falling off a wagon, and the public was informed that "Preston Woodall did not 'kick the bucket' but he took a severe fall trying to kick a bucket backwards."

It was announced on June 6 that Smithfield's second season would open July 27, 1899. Messrs. Shearin and Laughter and several other leading farmers reported that they would soon be curing and would be quite ready for the upcoming season. A month after the announcement, the *Herald* issued a poignant reflection on the effects of the past year's events: "Smithfield's rise as a leaf tobacco market has been rapid and phenomenal. On February 1, 1898, no one could have detected any life in our old town by the Neuse. The place was dead. The streets were deserted. There were no buildings in the process of construction. No means of employment were given the laborers of the community."

All eyes from the Old Belt and other veteran tobacco regions had focused on Johnston's new commerce. The faithful, as well as the doubters, were favorably impressed with Smithfield's venture into the tobacco world. The degree of local participation and unity was especially impressive. The high quality tobacco here was yet another source of raw material, supplying increased national and international demands. For the municipality, it was a promising new source of revenue, one which, by reputation, was unmatched in its capacity for generating value-added revenue. To the farmers, it was, at the very least, a supplement to the old standard bales of cotton, and at best, a higher per unit return replacement for those bales. To the warehousemen, it was yet another place to drum, or solicit, farmers for business. Warehousemen from distant markets randomly dropped in to try and retrieve some of their old Johnston County customers. Mr. A.S. Herndon, a Richmond, Virginia warehouseman, was among those compelled to visit Smithfield and solicit business. As for the social landscape of the county, there was an "aristocratic" air, as if Smithfield were part of the same history as the Jamestown and Williamsburg plantations, as well as the plantations of Richmond, Lynchburg and lands that joined, bordering North Carolina Piedmont tobacco plantation towns from the eastern plains westward to Danville.

Like most supply-demand driven commerce, pricing became an issue. As W. Duke and Sons became American Tobacco Company, clouds of discontent over the fairness in prices had, more and more, become a heated issue. It was not a new problem. There had always been tension between buyer and seller over quality and price. This was the premise on which the loose-leaf and auction sales methods had developed. Time, determination and varying degrees of harmony had spurred the industry on toward its present and comparatively efficient method of operation. However, a new monster, in a slow and predatory fashion, was rearing its ugly head. The problem was not just in prices, in which the farmers and warehousemen were directly affected, but control of the industry. The effects, which reached far beyond the boundaries of the farms and warehouse doors, sounded an alarm for all tobacconists—except one firm, American Tobacco Company.

A Story of the Tobacco Market Opening in Smithfield, North Carolina

With the gigantic explosion of demand for domestic and foreign sales and manufacturing, American Tobacco, under the direction of Washington Duke's son, James Buchanan "Buck" Duke, managed to grow at an amazing pace. His formula was straightforward and simple: wage an industrial war of attrition; buy up the competition! And if you can't buy it, kill it! "Buck" Duke was known and admired by many as a shrewd businessman, and he was hated by those at his mercy who saw him as a "greedy and ruthless thief." His daring business acumen was exceeded only by his determination to own it all. So far, his forward strides had seen no serious challenge. He had designed and nurtured a plan for American Tobacco, or the "Trust" as it had become known by many, to be the "octopus" that would enwrap the entire industry. Part of the Trust plan included the warehouse sector. The more he grew, the larger and faster he wanted to grow.

There was an existing law prohibiting monopolies, placed on the legislative books in 1890 by Senator John Sherman. The law was labeled Sherman's Antitrust Act of 1890. Even as Duke abrasively violated the act, no one bothered to apply it to his actions. But that was about to change. Public outcry began echoing louder and more frequently. Soon almost every newspaper called for his industrial obituary. Duke was soon brought to court and the monopoly he amassed from the early 1870s through the turn of the twentieth century was dissolved and the giant came tumbling down…the Trust was no more. To Smithfield, as well as all markets, the "Busting of the Trust" as some tobacconists referred to it, revived the competitive air that existed before the Dukes' postwar entrance into the business.

Courier-Times Accounts of the First Tobacco Market Opening in Roxboro

On the heels of Washington Duke's successful tobacco manufacturing enterprise, and the southward swing of tobacco production into North Carolina, market openings, like mushrooms, began to surface in towns that were equipped with the necessary supporting elements, such as easily accessible roads and railroads, et cetera. One of the most likely market locations was Roxboro, North Carolina, just below the already established Danville market town. On August 10, 1890, warehouse doors swung open in Roxboro. One hundred years later, Roxboro celebrated the first centennial of this opening.

The Roxboro-based *Courier-Times* newspaper did its usual superb job of giving extensive and expert coverage of the event, in an article printed on August 12, 1890 (reprinted here with permission):

> *Last week we gave notice that the Roxboro Tobacco Market would be opened for the sale of leaf tobacco on the 10th, and then the news began to spread and the remainder of last week when you would meet a farmer in town the first question he would ask would be, "Do you think there will be a big break Wednesday?" To that question we can now answer safely, YES.*
>
> *On Monday evening Mr. Weldon Whitfield brought in the first load of tobacco and drove to the pioneer Warehouse, that ended the arrivals until Tuesday evening, and then they began to come in quite lively and when dark came the two warehouses had about an equal number of loads.*
>
> *As the covered wagons would drive in town you could see squads of our business men standing on the street corners with broad smiles on their faces,—their long cherished hopes were about to be realized.*
>
> *Long years some of them had worked and planned for this very time, and now they saw their plans materialized, you couldn't blame them for smiling. No, they might have thrown up their hats and hurrahed at the top of their voices and then been excusable, for old Roxboro was getting ready to step to the front as a tobacco market and our people were jubilant.*

North Carolina Tobacco

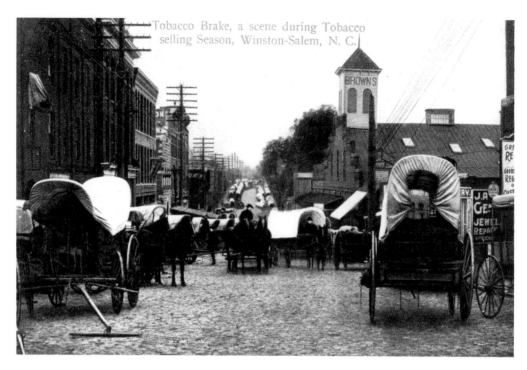

This scene of "going to market" is typical of the marketing days of the Middle Belt and Old Belt in North Carolina.

Wednesday morning bright and early the wagons loaded with tobacco begin to come in again just as lively as it did on the evening before, and at 10 o'clock the streets were impassible for the wagons.

At 12 o'clock the Pioneer Warehouse was formally opened by a short but ringing speech from our popular townsman, Mr. J.S. Merritt. He welcomed the buyers to Roxboro and prophesied a bright future for the Roxboro tobacco market. Then the sales began, with Mr. John Neal, of Danville, Va., as auctioneer. The first pile sold was Mr. Weldon Whitfield's and brought $64 per hundred, and was bought by that enterprising gentleman, Mr. H.A. Reams, of Durham.

At the close of the sales at the Pioneer the buyers took a recess for dinner, and about 2 o'clock the sales began at the Farmers' Alliance warehouse, that was, like the Pioneer, full to overflowing. Messrs. Pete Stevens, of Danville, Va., and Henry Dyer, of Durham, were the auctioneers, and they whooped up the boys about right.

Both warehouses were full and from the fact that the prices paid for the weed was high, enough tobacco remained in town over night to fill both houses today, and therefore we will have another good break. We heard a gentleman who was in a position to know, say that the prices paid yesterday were better than is generally obtained on such occasions and that there was less kicking by the farmers.

Everybody agreed that it was the biggest day Roxboro ever had and all were full of hope and encouragement for the future of our town.

Courier-Times Accounts of the First Tobacco Market Opening in Roxboro

Ole "Forty Dollar" John was certainly the antithesis of most farmers when their tobacco was sold.

Some buyers were also out in good force. In behalf of our people, we thank the gentlemen who came to Roxboro yesterday and bought so liberally, thus siding so materially in making our first break such a decided success.

The *Courier-Times* employed the talents of my longtime close friend, Bill Humphries, no less than one of North Carolina's most prolific agriculture writers, to help recapture the ambience of the 1890s. In the ensuing articles, Bill scans the happenings of the day the Roxboro Market opened, as well as a few other humorous happenings on the market there.

Auction System Amazed "Forty Dollar" John

Hard-working John C. Clayton, a Person County tobacco grower, was upset.

Like other farmers of the time—back in the 1880s—he was unfamiliar with the auction system of selling tobacco; it was just beginning to develop in the area.

Clayton took a load of leaf to Clarksville, Va. just to try out the new system. Buyers began bidding spiritedly for a pile of his good red tobacco, which was in style at the time. The normal price was $15 per 100 pounds.

John watched and listened in amazement as "those crazy buyers" ran the bids above $15 to $20, then $25, and on up to $30, $35 and even $40.

Clayton couldn't stand such foolishness any longer. He rushed out among the buyers, told them his tobacco wasn't worth $40, and begged them not to bid any higher.

To the end of his days, this honest farmer was known as "Forty Dollar" John Clayton.

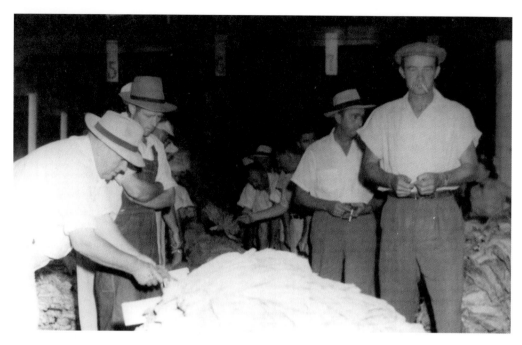

Farmers and warehousemen gather around a pile of tobacco to put last minute touches on the leaves.

Boyhood on a Tobacco Farm Recalled

Life wasn't easy on the tobacco farm in the Bethel Hill community where I grew up during the Depression years of the 1930s. But it would have been much harder if we had not had money from tobacco, our only "cash crop."

Until about 30 years ago, tobacco provided more than 90 percent of the cash income of farm people in Person County. For my parents and their eight children, it provided close to 100 percent.

Dad was fortunate to have six sons, for our hilly, rocky Piedmont farm was stubborn and yielded good crops only as a result of much hard work. We grew corn and hay for milk cows and mules, wheat for bread, and a family garden, but our lonely source of collars was tobacco.

Since we depended on the "golden leaf" for virtually every dollar of spending money for family needs, we tried very hard to produce and market a good crop each year.

We grew 15 to 20 acres of tobacco, perhaps more. When the price was low, we increased acreage in a desperate effort to maintain family income. In 1932 we sold much of our crop for a nickel a pound, and our average for the season was eight cents.

Yields were low, around 600 pounds to the acre. Even if we made a 12,000-pound crop, our cash receipts for the year seldom reached $1000.

Back in colonial times, in Virginia, Maryland and Carolina, tobacco "notes," certificates of ownership for so many pounds of leaf, were legal tender and were more acceptable than money.

Courier-Times Accounts of the First Tobacco Market Opening in Roxboro

Even minister's salaries were set in terms of pounds of tobacco. Without doubt, parishioners heard many sermons on the importance of growing a good crop "to please the Lord."

On the J.Y. Humphries farm where I grew up, most work was manual, not mechanical, and a great deal of it was backbreaking. Modern methods and techniques, modern chemical and machinery were virtually unknown.

Plant bed sites were rotated yearly and "burned off" for several days and nights before seeding to keep down plant diseases, dissects and weeds. Brush, leaves and logs were piled higher than a man's head. Even so, weeds appeared in abundance in the spring, along with the young seedlings. Removing weeds by hand was essential for a good supply of plants.

Transplanting to prepared rows in fields began when the seedlings were six to eight inches tall, usually in early May. If the soil was dry, we used buckets and dippers to apply water to each hill. The tool used for transplanting was a short wooden peg, around 10 inches long, pointed at one end and sandpapered to a smooth, slanting finish at the other.

The first cultivation, a week or 10 days after planting, consisted of "siding off" each row with a turn-plow, as close to the sides of the plants as possible. The crust of the strip of soil between plants was worked with a hoe, and dirt was pulled up around each plant.

At lay-by time, the crop was side-dressed with nitrate of soda, about a half cup to each plant, and a plow was used to throw dirt back up around the rows of plants. The final cultivation consisted of running a sweep down the middles between the rows.

Topping, worming and suckering were all done by hand.

"If I find any worms you've missed, you'll have to eat them," Dad warned. He never carried out this threat—but we took it seriously just the same.

During harvest season, we frequently had to get up at 3 a.m. to remove cured tobacco from a barn and get ready to refill it with green leaves. Priming was done weekly for six or seven weeks.

Wood was used for curing, which lasted four or five days and nights. The fires in the furnaces had to be checked every hour or so both day and night.

Cured tobacco was placed in the pack-house until stripping time, when the leaves were removed from the sticks for sorting and tying into hands or bundles. The tied bundles were placed back on sticks, packed until marketing time, and then taken to market by a mule-drawn wagon or a Model T truck.

We took pride in the appearance of our tobacco. It was handled and sorted carefully, dead and off-color leaves were removed, and the bundles were stacked neatly on the wooden baskets in the warehouse.

We know we weren't handling just tobacco. We were handling the source of our entire money income for the whole year. Good sales meant new shoes, a new dress for Mom, perhaps a suit for Dad. Only if we had a successful tobacco season could we hope to maintain our meager standard of living.

"First Warehouse Believed Erected in Oxford in 1866"

by Frances B. Hayes

It is a far cry from the days when Oxford had a single tobacco warehouse whose proprietor rang a bell when he had a load of tobacco to sell. Yes, it's a far cry, but the lives of some of us who have not yet grown accustomed (or at least, not reconciled) to hearing ourselves referred to as old men, span the two periods. Another far cry is from the days when the warehousemen went around among the merchants gathering up cash with which to pay the farmers, to the present when the banks handle the money and the warehousemen transact their financial business on paper.

Some of the really old men tell of even more primitive methods. They say that, in their memory, tobacco was carried to Durham and sold from wagons on the streets directly to the manufacturers, much as watermelons are sold today.

One of Oldest
Oxford's first warehouse for the sale of leaf tobacco was Taylor's, on what is now known as New College Street. It is believed to have been built in 1866, and it has been claimed that it was the first such building erected in North Carolina. Taylor's was followed in a few years by the Old Granville, which stood where Judge B.K. Lassiter's residence now is. In those days, Hillsboro Street, where the center of the warehouse business is now, was a residential section. The combined floor space of Taylor's and Old Granville would accommodate about as much tobacco as would fill two or three rows of a present-day warehouse. These two houses were equipped with bells which called the buyers to sales. At first, these sales were held on Tuesdays and Fridays, and for many years afterwards Tuesdays and Fridays were the big days on the tobacco market here.

Buyers Then and Buyers Now
In the olden days the selling season extended all year round, not from mid-September to early spring as at present. Anybody could buy tobacco on the warehouse floor who wished to do so. The warehousemen encouraged impecunious buyers by extending them

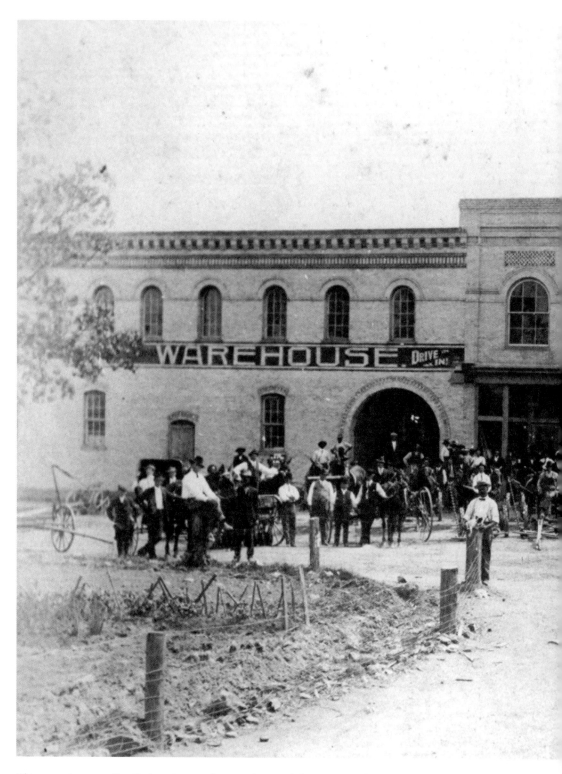

This scene is reportedly of a late nineteenth- or early twentieth-century gathering at a tobacco warehouse in Oxford. It exemplifies the mood at the market openings in North Carolina market towns.

"First Warehouse Believed Erected in Oxford in 1886"

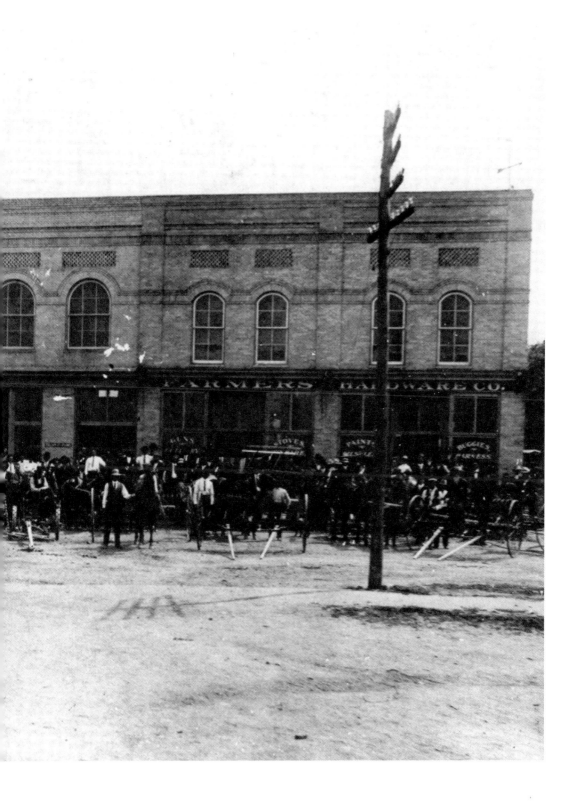

credit until they could realize on their purchases. Every buyer was an "independent" in those days and most of their purchases were sent to Commission Houses in Richmond, from which manufacturers drew their supplies. Some of the more firmly established buyers had regular customers from whom they bought on order.

That too, is a far cry from the present method, when eight or ten manufacturers and exporting companies maintain a double set of buyers on the Oxford market and employ corps of men and women to recondition their tobacco before shipping it to their own storage houses to mellow. In the older days tobacco was hung in large and airy lofts for weeks and months until it became in proper order (right degree of moisture) for priming and shipping. These prime houses dotted the landscape. A few of them still remain but are used for other purposes, as tobacco is now reconditioned by machinery in a few hours.

Oxford Boosted by a Railroad
For many years the two warehouses named were the only such establishments in Oxford. Then came the first railroad. At once the market took on new life. Even before the coming of the "iron horse" in 1881, two new warehouses had sprung up in anticipation of its arrival, the Johnson and the Banner. Their opening sales were held in January 1880. Each of these houses was of frame construction and, while large for its day, would be ludicrously insufficient now. They were burned to the ground in Oxford's biggest fire, March 15, 1887.

In those days annual sales were spoken of in thousands of pounds instead of in millions. However, as these sales were spread out over twelve months, little warehouse space was needed. Hauling tierces of tobacco twelve miles to a railroad station over roads that were frequently axle-deep in mud was no small matter and had been a heavy handicap to Oxford's growth as a tobacco market.

In less than a year after rail connection had been achieved, another long step forward was taken—a bank was established, enabling warehousemen to pay by check rather than in cash and thereby greatly facilitating the handling of a big break. Oxford, as a tobacco market, was forging to the front.

Granville County Father of the Eastern Market
Fifty years ago a tobacco plant was as much of a curiosity in eastern North Carolina as cotton plants in New England today. Wilson's first tobacco warehouse was opened in 1890. The bright tobacco belt of North Carolina previously had extended from Granville County westward for a hundred miles or so and not so very far from the Virginia line. Granville men went east and showed farmers how to make tobacco and then developed the pioneer markets of that section, especially that of Wilson. Later, Granville men went to Canada and established the bright tobacco industry of the dominion. For many years past, men from this county have been playing a leading part in the tobacco belts of South Carolina and Georgia, as well as of Europe, Asia and Africa, and even the islands of the sea.

Most of the tobacco grown in the bright belt these days goes into cigarettes. As late as a decade or two following the War Between the States, a great deal of the crop in

Granville and nearby counties was made up locally into smoking and chewing tobacco and sold from wagons in the eastern part of the state.

Increase of Cigarette Smoking
But for the fact that cigarette consumption has increased by leaps and bounds during the period now under notice—from about 16 billion in 1914 to something like ten times that number now—there would have been no incentive for the farmer of the newer belts to grow the golden leaf. When the writer was a lad he was acquainted with two Granville men—one a near kinsman—who took cigarettes to the Orient, gave them away and taught the "yellow men" to smoke them and like it. Always on the lookout for a wider market, the cigarette manufacturers have, in comparatively recent years, taught women to consume the little white cylinders and thus to increase the manufacturers' profits. In the olden days few women smoked, and those few usually were old and ugly and confined themselves to their pipes. As to snuff-dipping, however—well, that's another story.

Note: Many factors influenced the opening of tobacco market facilities. First, environmental conditions had to be suited for tobacco production; secondly, there had to be a collective and concerted community effort to provide easy "farm to market" access. This meant that roads had to be built, especially railroads, which could provide rapid transport of tobacco from the warehouse to faraway processing and manufacturing facilities. With the opening of long distance rails, Oxford became a major influence in marketing.

This article by historian Frances Hayes was originally published by the *Oxford Public Ledger* in 1966. (Reprinted with permission.)

"Tobacco Tales, Told from the Ground Up"
by John Barbacci

Forged by the hot summer sun, kindled by the soil of a Southern field, is the tale of a plant that practiced its power of predictability on the lifestyles of many North Carolinian tobacco farmers in years previous and still today. Fashioned by the flue of flame, tobacco growth, curing and selling, has held within its leaves the authority to either bring a man to wealth or shame.

Having minimal esteem for Southern living, due to my undersized knowledge of its worth, I was once ignorant of the tremendous value and richness that Southern heritage encompasses. An overflowing abundance of family virtues, weaved into a society of hardworking, dedicated, relentless folk, who found union in the fields of farming, inspired me to have a new perception on the necessity, and irrevocability of the influence that tobacco has had on the South. After being availed the opportunity to peep into the past, by interviewing several Southern veterans of the tobacco industry, who have toiled with the trials of tobacco either in the fields or the files that such an occupation involves, I became acquainted with its dearly influential history.

Kuther Debro Stancil (K.D.), an eighty-six-year-young man unraveled the importance that growing tobacco has had on his life. Before the Civil War, Elizabeth Stancil, K.D.'s grandmother, bought a thirty-acre plot of land in Kenly, North Carolina, for fifteen silver dollars. This plot of earth she and her family cleared in aspiration to plant a crop of tobacco, to earn their wage.

Soon after the War, Elizabeth passed on her farm to Debro Stancil (K.D.'s father), who preached at churches on Sunday morning. Debro, every Sunday, hitched his humble box wagon to the family's farm "plug" (a name given to the old mules) and traveled to one of four churches to minister. According to K.D., farming folks usually only went to church once a month because it was such a journey to get there, so Debro rotated between four churches to carry out his ministry. Unfortunately, Debro's duty to the parishioners of these four churches didn't supply him with a sufficient income to support his estate. "I remember when daddy made $16 for the

North Carolina Tobacco

Mr. Kuther Debro Stancil.

"Tobacco Tales, Told from the Ground Up"

whole year one time," which makes it hard to explain why Debro continued in the occupation of his heritage.

At the tiny age of five, Kuther recalls working with his father driving mules to and from the tobacco barns and field. K.D. learned early in his life that the process from seed to sale required everything.

While it was still held within the jaws of January's ice influence, Kuther was taught how to sow the tobacco seeds in a small garden covered by a cloth-like net (a plant-bed cloth), to keep down the fatalities that frost brings to the baby plants. The gardens covered by cloth have now been replaced by greenhouses to produce a much larger quantity of quality tiny tobacco plants.

Once the tobacco grew to about six inches tall, it was then transferred into a transplanter and taken to the fields.

All my interviewees, who grew up in tobacco during this time, were quick to mention that it was common practice for neighbors to aid one another in the tobacco growing process. In the personal accounts that Ruth Daniels—a woman who was born in 1929 to a lifestyle of farming tobacco—shared with me, the biggest role in her reminiscences was the neighborhood camaraderie. With a look of repugnancy, Ruth quickly brought up the first thing to her mind: the tobacco worms. As a child, Ruth's job was to pull off tobacco worms that were seeking to gobble up the precious crop that her family solely depended upon. Just like Ruth, Kuther also had a childhood job. His was pulling suckers from the tobacco plants.

Kuther allowed as to how "'backer' [tobacco] gum is sticky, I'd have to boil my clothes to get it out." There's not a place that tobacco sap wouldn't get embedded into. Mr. Stancil also commented how black his hands would be at the end of the day, "Sometimes I couldn't tell what color my hands were."

This need to get the job done, no matter the circumstance was well remembered by Kuther as he told me, "It didn't matter if it was raining or storming, I was out there working to get the job done," then he looked at me and remarked, "It makes me tired just thinking about doing that work." K.D marveled at the intensity of the work and that people would do it at such a low wage: "It was a wonder anyone would ever do that work for such a small pay at 7 $\frac{1}{2}$ to 10 cents an hour." While chuckling, Mrs. Ruth told me a story that one time she was so frustrated with the work out in the fields, exhausted by the hot sun and hard labor, that she ran up to the house, set the clock forward an hour then rang the dinner bell so she could be done for the day.

When the time of crop harvesting came, the whole neighborhood, once again, united with the same objective to tackle it. K.D. mentions that it was usually accomplished by at least four men in the field.

Kuther described to me the priming process involved in gleaning the tobacco. "There is four stages of priming a tobacco stalk," K.D. started off, "first to be primed is the 'Prime,' or 'P' tobacco, which is the tobacco that's furthest down on the stalk. Then next the 'lugs' ('X') was collected, followed by 'Cutter' ('the best on the stalk') and finally the 'Leaf' ('B'), which went from about midway down the stem to the top." When I asked him how it was that he knew when to harvest, Kuther accurately answered that it usually

North Carolina Tobacco

Ruth Daniels.

"Tobacco Tales, Told from the Ground Up"

Tracy Daniels.

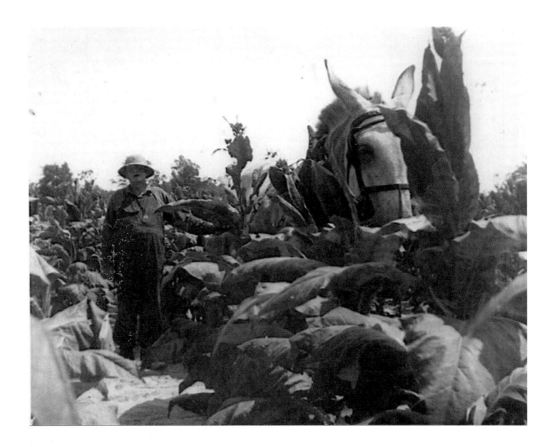

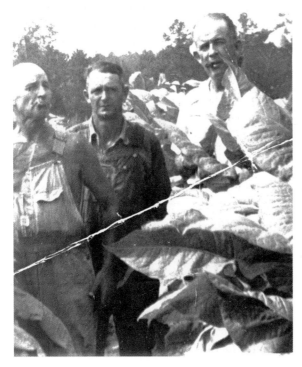

Above: Albert Ray Stephenson stops "priming" tobacco long enough to pose beside his prized white mule.

Left: Three Granville farmers, *left to right*: Mac Satterwhite, Garland Jones and Wilbur Yeargin, stop long enough to pose for the camera. Circa 1954.

occurred in late August and into September, taking about five weeks for four men. The leaves of the tobacco turn a nice yellow/light-green color, and "a white blossom sprouts from the top of the plant," indicating its maturation.

Once the tobacco was picked, it had to be transported to the barn—a job that both Ruth and Tracy remember doing—and was a task that "usually the children did." Tracy Daniels told me that was her initial memory of working in the tobacco fields, "ever since I could walk, which was barefoot, by the way, I recall laying leaves of tobacco in a sack a certain special way, that was then hauled off by mules to the barn." Mrs. Ruth was familiar with this part of the job as well. As a community effort, the children of the farmers would also go from farm to farm helping in the farming process. One of Ruth's main undertakings was hauling the leaves of tobacco to the barn: she, at such a young age, drove the "plug" mule that pulled a slide, which was a wheel-less device used to haul tobacco.

"One thing that I really hoped to see when I went to my neighbors' farm was a truck [a slide with wheels]," Ruth commented, because it was so much easier on both the mule and herself to manage the truck.

Then the tobacco was unloaded at the barn where Kuther would usually adjoin tobacco stems (get them even at the head of the leaf) then pass them off to another person, such as Ruth, who tied the tobacco together with tobacco string, while attaching twenty to thirty bundles of tobacco per stick. Dangling with around fifty pounds of tobacco leaves, the sticks were then fastened to one of the seven rafters (at least in K.D.'s barn) in the barn, holding four hundred to five hundred sticks per tier.

"Do you want to know why this process is called 'flue-cured'?" K.D. asked me with a grin on his face, for the first time in our chat. Having no knowledge of the field, I gladly listened to his explanation: "Well, it is because there are flues that carry heat that is generated by a furnace inside the barn. These flues go through the barn heating it up then the smoke goes out through the flues on top of the barn."

The leaves on sticks would usually be cured for three to four days; the first day the furnace was set to around 100 degrees, then the next day rose to 120, and nearing the last day or so, the furnace temperature was elevated to 165 degrees. By the end of those few days, that fifty-pound stick would then weigh around two pounds; the ceaseless flow of heat swiftly shriveled the water-swollen leaves, but had to be monitored so that the leaves would not get so dry and crack. Ruth remembers the times that it was her duty to awake in the middle of the night and run out to the barn to open the little barn door, allowing some humidity in to prevent the tobacco from crumbling.

The freshly flue-cured tobacco was then removed from its stick to be stacked neatly on a four by four basket where it would then be hauled away to a warehouse to be sold.

A tobacco farming career exhausted many farmers and their families, including Kuther, Ruth and Tracy. According to Mr. Jessie Thomas Bunn, or Tommy, manager of government affairs and a veteran tobacconist with the Flue-cured Tobacco Cooperative Stabilization Corporation, these were the victims of a great gap in monetary payment in comparison to the profit that the private corporations who distribute the tobacco gained. An adage that Kuther said he'll never forget his father saying in reference to the

North Carolina Tobacco

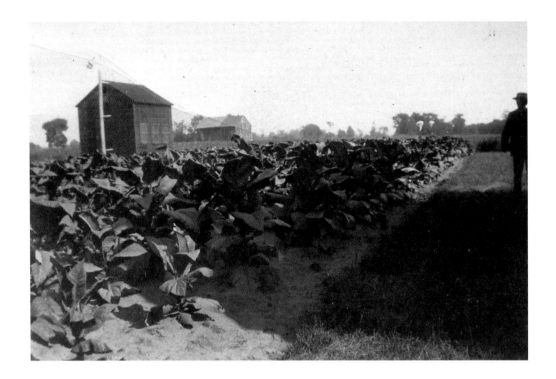

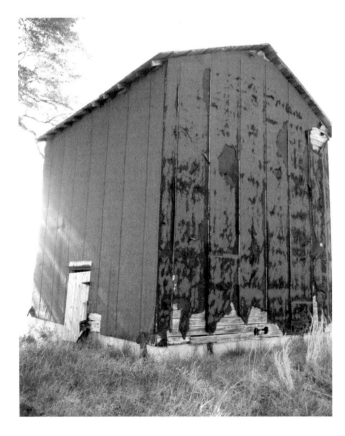

Above: Sometimes the distance from the field to the barn, where all the shade was and where the cool drinks and water were, seemed twice as long as it actually was. The site here is a familiar one to any child responsible for "driving [tobacco] slides."

Left: Mr. Stancil's barn.

"Tobacco Tales, Told from the Ground Up"

A sign of progress in the methods of supplying artificial heat under the "flue" method of curing tobacco.

consequences of getting a small portion of the large proceeds was: "5 cent cotton, 40 cent meat, how in the world can a poor man eat?" Since neither cotton nor tobacco can be eaten, the farmer had to sell his tobacco at the local warehouse.

According to Frank Lee, an experienced tobacco farmer and warehouse operator, before 1998 all tobacco was brought in "sheets," which is layered tobacco carried in a large burlap bag that could only hold about 200–250 pounds of tobacco.

As Mr. Lee explained, while the sheets got the job done that they needed to perform, the burlap did have some disadvantages.

The burlap bags accounted for 10 percent of spilled tobacco, which came out of the sack simply due to its multiple rearrangement in the warehouse, compared to losing only one-tenth of a percent that a bail lost. One other disadvantage to sheets is that they took up so much room. Tobacco the farmers brought in had to be sold and shipped out to the refineries soon because if it wasn't, then the warehouse would quickly get cramped with crops.

But to the advantage of Frank and many other warehouse operators was the introduction of the bailer, a welcomed space-saving wonder. The first hydraulic tobacco bailer ever introduced in the United States was prototyped in Frank's warehouse. The bailer was brought to Mr. Lee by Phillip Morris, who asked him to try it in hopes of its success. It was, in fact, successful. Today the warehouse takes strictly bails of tobacco

Frank Lee showing a look of satisfaction at the burley prices in Johnson City, Tennessee.

that have the capacity to contain 850 pounds of product, a massive amount compared to its puny predecessor, the sheet.

Before 2003, when the Stabilization Program came to a close, the tobacco was brought in by farmers, and it traveled down a conveyor belt to be first graded by a government official—as Mr. Stancil once did—then an auctioneer would bid the bails off to the highest offer in most cases. "Sometimes the farmers would let the government buy the tobacco," Mr. Lee informed me, and I then proceeded to inquire why such a denial of funds would occur. He looked at me and said, "John, that's just a farmer being a farmer."

However devious the government may seem to the farmer, the State has aided farmers in many ways over the past century in the farming arena. In 1933 the birth of the Tri-state Cooperative consisting of North Carolina, Virginia and South Carolina was a program created in effort to assist the farmer by leveling out tobacco costs, but it eventually failed due to such "fluid tobacco prices," according to Tommy Bunn. But the government didn't forget about the people it began to help. Another plan was constructed on June 1, 1946, called the Flue-cured Tobacco Cooperative.

According to Mr. Tommy Bunn, this substantial support to the tobacco farmers was first created to "prevent dramatic fluctuation in prices of tobacco that was encountered

in the market place." Such a task was to be undertaken by the removal of production fluctuation, called the Tobacco Adjustment Act, which was in effect by the producers at this time in history. This initiation of stabilizing both production levels and set prices fostered a much-needed environment of constancy. These governmental programs had the appearance of longevity because they were passed by legislation, which, in Mr. Bunn's words, "didn't have to be renewed every five years, but instead were 'permanently' legalized."

In 1946, much of this stabilization dealing with production was based on the previous ten years of a farmer's yield of tobacco that was averaged together to give the farmer a weight in tobacco per acre that he was allowed to produce, or rather sell in the market. Then those who were allotted an amount of permitted production, and who had a history in farming tobacco, were immediately admitted to the Flue-cured (FC) program with a fee of five dollars, solely for the purpose of keeping track of the farmer's history. For those who were not farmers of tobacco, but wanted to be, they had the obligation to buy a farm and accept their allotment concerning their production limit.

The economic formula that served as a contemporary model for the Flue-cured Tobacco Stabilization Cooperation is the New Deal. Being modeled after a Franklin Roosevelt program that was based on parity-index, tracking reappearances of prices whether inflated or deflated on tobacco, made it much more influential in the political stance, more so than the Tri-state Cooperative.

By providing the local community with a dependable, stable annual income, the farming society undoubtedly embraced the consistent cash flow. "Oh sure it made a difference," Mr. Stancil exclaimed when I asked if he personally felt the federal, financial fingers of fidelity. Mr. Bunn continued to explain the effects that government initiations played on the farmer. He cited that this new flow of finances for the farmer allowed him to have the liberty to borrow money against their crop with confidence because of the nearly guaranteed government gratuity. This inevitably allowed local farmers to put more cash into their community by building new schools and churches, which, along with higher tax payouts, led to better roads and even improved the institutions of higher education such as: Duke University, UNC Chapel Hill and NC State University. "Many people," said Bunn, "reject the less than desirable effect that tobacco consumption ultimately has on its consumers, but embrace the local, state and national economic benefits it produces."

However great the local, and perhaps state, impact tobacco has made on society, the biggest economic mark that tobacco has made recently has been on a more macro level. Mr. Bunn agrees with Frank Lee in saying that China is not only on the rise in international trade, but is at its forefront. The Chinese have been in tobacco business with the United States since the 1950s, but weren't heavily hunting an increased supply of American tobacco until 1992. Since the early nineties China has picked up its request for more tobacco. Tommy made the comment that it wasn't until two seasons ago that the Chinese really began to show their demand for American tobacco.

Frank Lee mentioned that a simple pack of "lesser" cigarettes, of no significant splendor, costs the Chinese around fifteen dollars a piece. If a Chinaman desired a more delicate smoke ("regulars"), it would cost the hefty price of thirty to forty dollars.

A simple pack of "lesser" cigarettes, of no significant splendor, costs the Chinese around fifteen dollars a piece, compared to a pack of "regular" cigarettes, which costs between thirty and forty dollars a pack.

Returning to domestic affairs, the kind of economic stabilization offered to members by the "program" is still fulfilling its main service objective to those who have contracts with the Flue-cured Tobacco Stabilization Cooperation predecessors. These contracts allow farmers freedom from being completely reliant upon private companies to purchase their product. Such an absence of the cooperation's security could be detrimental to the growth of a tobacco community. Another security provided by this institution was a program stemming from the FC program, being the No Net Cost—which consisted of the government setting aside a portion of the farmer's income in a "money bank," used in case of an economic downfall for the farmer. Lee gave me some descriptions of these "perils"—the natural catastrophic occurrences such as a drought, flood, a diseased crop and so on.

However much the Flue-cured Tobacco Stabilization Cooperation grants in assistance to farmers, in Mr. Bunn's eye, it would be incorrect to say that it is a "subsidy" because the federal funds that are put into the program are not expected to return, but rather the surpluses are used to aid other agricultural programs under the governmental umbrella.

One of the social and cultural fallouts of the Loan Support Program was that it allowed people to "sharecrop" to such an extent that the people renting the owner's

"Tobacco Tales, Told from the Ground Up"

Fred Bond, long-standing CEO of the Flue-Cured Tobacco Cooperative Stabilization Cooperative, led the co-op through many years of progress and change. No doubt, he was one of the most respected tobacco leaders of the late twentieth century. Here, in April of 1980, Fred is flanked on the left by Bill Parham, then deputy commissioner of agriculture, and Charlie Finch, assistant to Mr. Bond, who later became CEO of the Burly Tobacco Cooperative.

land ended up purchasing the ground for themselves, breaking up the land in division. This separation of ancestral borders is something that Frank Lee personally experienced. He mentioned that his father was born in 1929, and always had a "Great Depression attitude." "If he couldn't buy it cash, he didn't buy it," said Lee. This kind of approach to finances led to him having to sell much of his land that had been in the family ever since the early 1700s. Frank, being intrigued by his lineage, was gratefully able to buy back what his father sold. Mr. Lee's story is a fortunate one, in the context of Mr. Bunn's explanation of the fruits of the program, a tale that not everyone is able to tell.

In 2004, the program was terminated due to a continual margin between world value and local prices. At this time, its supportive assistance to the farmer was ended.

Even with the program now gone, the tobacco industry continues. The warehouse continues to clean the farmer's product and the private and governmental organizations persist in purchasing it. But the services furnished by the warehouse come with a fee. According to Frank Lee, the warehouse charges the farmer twenty-five cents per each bail sold, followed by a ten-cent charge for every one hundred pounds of tobacco auctioned off and finally a commission of 2.5 percent of all the farmer's net gain.

North Carolina Tobacco

Here, Stabilization CEO Fred Bond is shown examining the quality of flue-cured tobacco on the cover of the *Flue-Cured Tobacco Farmer* magazine, illustrating a modern-day hogshead of tobacco.

"Tobacco Tales, Told from the Ground Up"

Freshly turned soil set with tobacco for the growing season.

 Once the refineries take the flue-cured tobacco, it is conglomerated with a sundry of different other tobacco types, such as: burley cured tobacco, oriental tobacco and some dressing tobacco, which is for different types of flavors.
 A life bathed by the battles of political, economical and social bindings and benefits, those in the tobacco industry have won over my respect of their persistent work ethic and good-heartedness. A humble and honorable occupation, the farmer knows all too well tobacco's tale from "seed to sale."

Note: John Barbacci is a student at Johnston Community College. (Reprinted with permission from an essay on reflections of the tobacco community.)

"Tobacco, Seen 'from Other Side of Desk'"

In April 1978 Horace Kornegay, president of the Tobacco Institute in Washington, D.C., and I sat reminiscing over dinner about the "good ole days" growing up around tobacco barns and in the fields of North Carolina. We agreed that every American should know just how tough tobacco farmers have it. "Most people," said Kornegay, "wouldn't last a day in a tobacco field. They couldn't stand ten minutes under the hot sun at three o'clock in the afternoon."

"Billy," he said, "maybe you ought to set yourself up a media tour around the country and explain to folks in air conditioned places like New York City and Chicago and Los Angeles just what it means to plant and grow a crop of 't'bacca.'"

"What about these people on Capitol Hill, here in Washington," I said. "They need to know more than anyone else." Kornegay agreed. Then I added: "Why don't we start with the ones who are working for the Institute. Let's take them all down to North Carolina and give them a day or two in a tobacco field, taking out a barn of tobacco and going to the warehouse to see a sale. I'll bet none of your staff has ever had to sweat like a tobacco farmer. Let's give them the opportunity to do that."

"Let me think about that," said Kornegay. Two days later, I got a call from Kornegay: "When do you want to do it?" he asked. "August is the best time," I said. "Good," he said, "set it up and I will give the entire staff the opportunity to spend a day as a tobacco farmer."

On August 17, 1978, seventeen greenhorn staff members of the Tobacco Institute rolled into Henderson, North Carolina, ready to learn about the grass-roots side of tobacco. And *Durham Herald* staff writer Sherry S. Freeland covered the event in her article "Seen from the Other Side of the Desk, "reprinted here with permission of the *Durham Herald*.

> OXFORD—*When the executives from the Tobacco Institute left their air-conditioned bus Tuesday and headed for the tobacco fields, they were minus their three-piece suits or high-heeled shoes.*

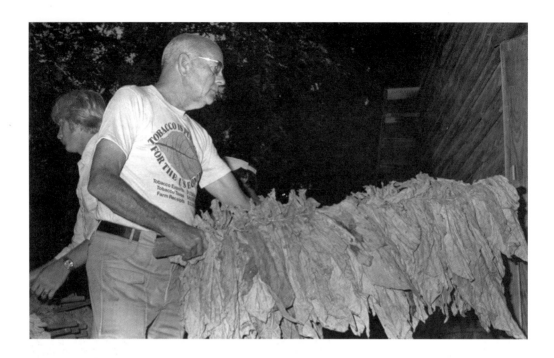

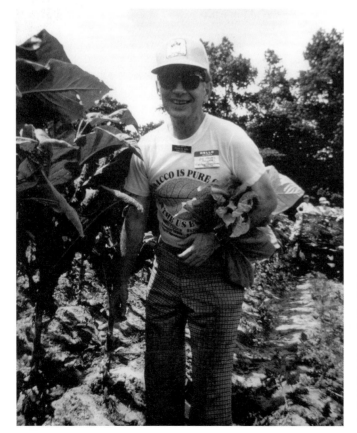

Above: Blucher Ehringhaus, senior vice-president of the Tobacco Institute, at 5:30 in the morning, taking out a barn of tobacco.

Left: The media joins in the fun! Dix Harper, *Farm News* reporter for Capital Broadcasting, smiles for the camera as he holds an armful of tobacco. It's 3:00 in the afternoon!

"Tobacco, Seen 'from Other Side of Desk'"

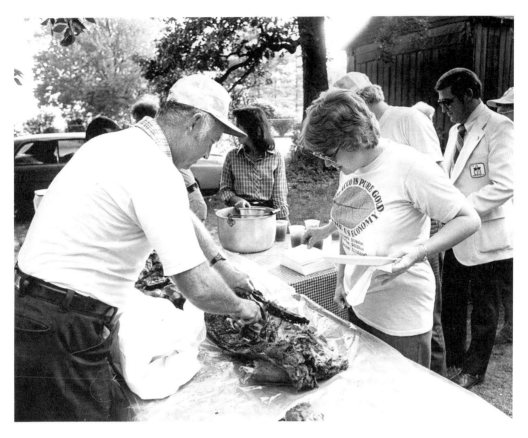

It's the first time the Tobacco Institute staff has ever had a good old-fashioned pig-picking. Local folks help serve up the pig. *Left to right*: Wayne Overton, Kim Yeargin and Anne Shelton.

Instead they wore jeans, hats, scarves and old tennis shoes. And even before a good five minutes were up, you could hear their moans and groans.

Muscles popped, sweat dropped and a flurry of sand settled on the lush, green tobacco plants.

Blucher Ehringhaus, senior vice president of the Tobacco Institute in Washington and son of the late Gov. John Ehringhaus, warned the 17 people he brought with him about the hazards of worms.

"And listen, if you see any worms you're supposed to pull their heads off."

Some looked at Ehringhaus like he had been in the sun too long. Some giggled. Some looked a bit apprehensive.

Billy Yeargin, managing director of the Tobacco Growers Information Committee, Inc. in Raleigh, had invited the executives to North Carolina for a "Grass Roots Tobacco Day." He wanted them to learn about tobacco "from the other side of the desk." That is, when it's green in the fields.

Yeargin got the Washington crowd up at 5:30 a.m. and took them over to his tobacco farm to remove some cured tobacco from a barn.

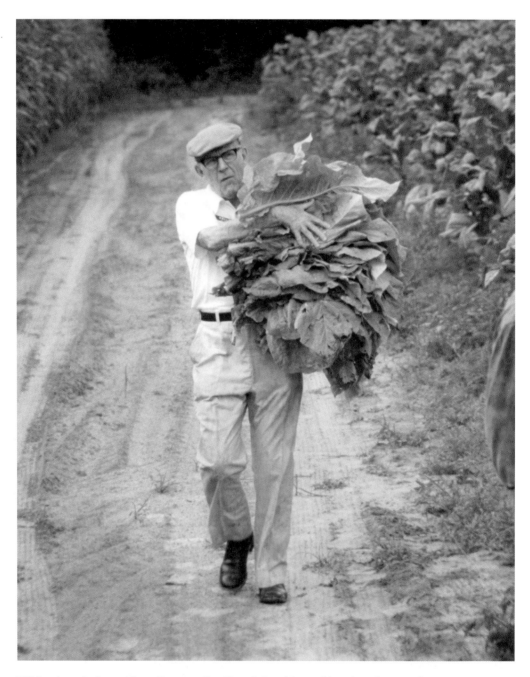
Bill Lewis, agriculture aide to Governor Jim Hunt, brings his armful to the tobacco trailer.

"Tobacco, Seen 'from Other Side of Desk'"

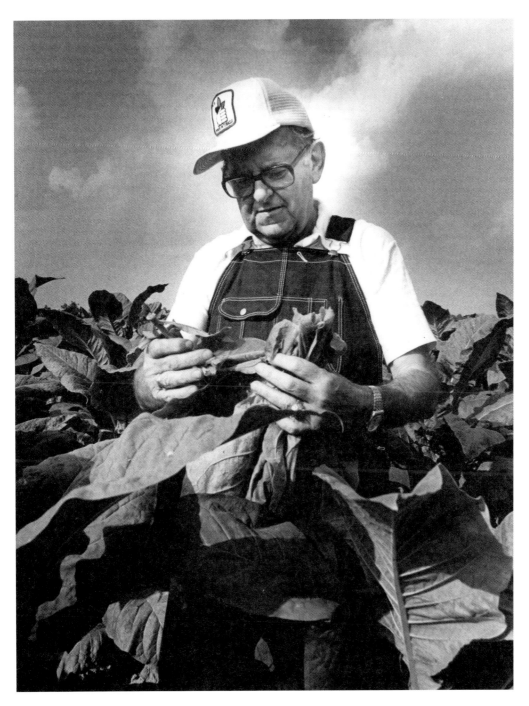

No one is exempt from working. North Carolina Commissioner of Agriculture Jim Graham smiles at a handful of good ripe tobacco.

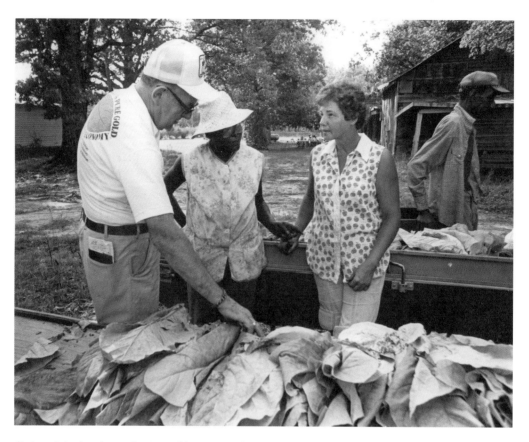

Graham joins in tying or "stringing" leaves out of a tobacco truck.

Mike Craig, director of media relations at the tobacco institute said, "I learned one thing about tobacco out of the barn. When a man standing above you in a barn hands you one of those tobacco sticks, you don't look up at him to take it."

Craig, who kept wiping sweat from his face, said tobacco dust got into his eyes "and boy does it sting."

Craig grew up in Augusta, Maine. He said the closest he's ever been to a tobacco field before coming to North Carolina was "about 100 yards. If I couldn't see it from the road, I didn't see it."

He said he'd like to come back to North Carolina and visit because "these farmers are good, hard-working people; they're friendly."

"I wish the enemies of the tobacco industry could come down and meet these people who work in the tobacco. The enemy thinks of these people as a bunch of ogres," Craig said.

Walker Merriman, assistant to the president of the Tobacco Institute, has been to this state before, but always to attend meetings.

As he took the quarter-mile walk from the bus to the fields, he explained that he had gained "a tremendous respect for the farmer after this exposure. And we've learned a

lot…those of us sitting behind a desk. We'll be getting a chance to use some seldom-used muscles."

A pig-picking was scheduled after all the work was done. Before the group got to the fields, they had breakfast at a country store and lunch at the Oxford Country Club. Then there was a visit to some tobacco markets.

Carroll McNally, research analyst for the Institute, said the auction was "just fascinating. I don't know how these people are able to work like they do."

Ms. McNally had a bunch of tobacco neatly tucked under her right arm. Yeargin, who was dressed in his jeans and sunglasses, had patiently explained how to properly pick tobacco.

He explained about suckers and asked everyone to pick only three leaves off of each stalk.

One man looked up as he reached for a leaf. "Should I pick the old yellow one or the nice green one?" he asked.

"Just pick one," Yeargin said, smiling, "Any one, this time."

"TOBACCO TOWNS: URBAN GROWTH AND ECONOMIC DEVELOPMENT IN EASTERN NORTH CAROLINA"

BY ROGER BILES

Much of the limited urban growth that occurred in post–Civil War North Carolina was owed to the increased manufacturing of tobacco, the South's oldest staple crop. In the late nineteenth century, the state's dominance of the expanding tobacco industry resulted from several factors—declining cotton prices that induced Tarheel farmers in the Piedmont to plant more tobacco, technological developments that initiated the mass production of cigarettes, improved railroads that connected North Carolina with national and international markets and the bold entrepreneurship of men like James B. Duke and R.J. Reynolds, who formed vast monopolies and drove less ruthless competitors from the field. The success of Duke and Reynolds brought Durham and Winston, the communities in which they located their enterprises, to the forefront of the state's emerging urban network.

From 1880 to 1900, Winston's population grew from 443 to 10,008; Durham, which had been omitted entirely from the 1870 census, claimed a population of 6,679 by the turn of the twentieth century. Just as the iron and steel industry dominated the economy of Birmingham, Alabama, and textile production controlled life in the mill towns dotting the hills of the Carolinas and north Georgia, the tobacco factories literally and figuratively towered over the cityscapes of Durham and Winston, North Carolina.

The burgeoning tobacco industry also shaped the development of a number of smaller and lesser-known communities in eastern North Carolina. These towns grew rapidly in the late nineteenth and early twentieth centuries and became the principal marketing centers for tobacco cultivated in the state's inner Coastal Plain. This presentation considers the four communities that grew and prospered most because of the tobacco boom—Wilson, Kinston, Greenville and Rocky Mount. (Although they developed into less prominent marketing centers, such communities as Goldsboro, Tarboro, Williamston, Farmville and Robersonville similarly grew along with the tobacco trade.) In all of these areas, the continued significance of agriculture underscored the strong ties between the city and the countryside in the nation's most rural region. To a remarkable extent,

life in those communities followed the seasonal changes associated with the cultivation and marketing of a single agricultural product. In short, Wilson, Kinston, Greenville and Rocky Mount became "tobacco towns" in the New South, and their development remained closely linked with the crop for decades.

Widespread cultivation of tobacco commenced in the North Carolina Piedmont in the mid-1800s, largely owing to the introduction of a new variety of the crop. European consumers (especially the French) criticized the dark, heavy leaf raised and fire-cured in the United States, and expressed interest in tobacco with a milder flavor. Farmers in Maryland, Kentucky and Ohio experimented with new soils, crop genetics and curing methods but made limited gains. The soil and climate of southern Virginia and northern North Carolina, however, favored farmers who perfected the production of an aromatic yellow leaf that revolutionized the tobacco industry. Ironically, while a tobacco plant growing in rich tidelands soil produced a dark, heavy leaf, the same plant grown in less desirable siliceous soil lacked several nutrients and yielded the thin yellow leaf sought by Europeans. Thus an area of relative poverty in the North Carolina Piedmont proved to be the center of a tobacco boom that enriched the region for generations. The Old Bright Belt, as it came to be called, encompassed Pittsylvania, Halifax and Henry Counties in southern Virginia, as well as Vance, Granville, Durham, Person, Orange, Alamance, Caswell, Guilford, Rockingham, Forsyth and Stokes Counties in northern North Carolina.

The perfection of bright tobacco depended upon new and improved curing techniques, as well as on proper soil. Forsaking the old practice of curing tobacco over slow-burning wood fires, farmers throughout Virginia and North Carolina experimented with a variety of fuels and procedures to produce the crisp, aromatic yellow leaf favored by buyers. The optimal method adopted by farmers after much trial and error involved the combustion of charcoal instead of wood for fires and the use of flues or ducts to convey heat within the tobacco barns. While farmers kindled fires outside the barns, flues inside distributed heat throughout the structures and eliminated smoke and fumes.

Successful and struggling farmers in the region soon retooled to grow bright tobacco. When domestic manufactures began using the yellow leaves as wrappers for twists of plug tobacco, market prices for the new product shot even higher. "Many persons have taken to growing tobacco within the last year or two who probably never raised a plant before," commented the editor of the *North Carolina Planter* in 1858. By 1860, bowing to the request of their readership, both the *North Carolina Planter* and the *Southern Planter* published instructions for the cultivation and curing of bright leaf tobacco. Regarding the latter, the journal editors instructed their subscribers to use small quantities of charcoal, maintain high temperatures night and day, build barns with several windows to ensure adequate ventilation and use thermometers to maintain temperatures in the barns. Armed with an exact blueprint for curing, even farmers in remote areas mastered the procedures that made growing bright leaf tobacco profitable. By the mid-1860s, acreage in the North Carolina Piedmont sold at a price twenty to thirty times greater than it had only a few years before.

Prior to that time, Wilson, Kinston, Greenville and Rocky Mount languished as tiny mercantile centers for a developing trade and transportation system in the midst of an

"Tobacco Towns: Urban Growth and Economic Development"

agricultural hinterland. Cotton initially attracted settlers to the region and remained the most important crop until it was supplanted by tobacco in the 1880s and 1890s.

Desperate for a new cash crop, eastern North Carolina farmers followed the lead of their prosperous Piedmont counterparts who were planting tobacco fence post to fence post. Although the paucity of records makes it difficult to be certain, tobacco cultivation east of the Piedmont may have begun in 1878, when Arnold Borden harvested several acres of the crop in Wayne County. Thomas York, a Nash County farmer who had recently relocated from Granville County, transported tobacco to market in 1883. In 1885, Thomas V. Avent, a prosperous farmer who lived near Rocky Mount, harvested an unprecedented seventy acres of the new crop. Observing that Nash County farmers successfully grew tobacco in the same sandy soil that predominated in Pitt County, Leon F. Evans hired a Granville County adviser and planted tobacco on his farm west of Greenville in 1886. His crop not only brought a handsome profit at harvest time but also won a prize for the best tobacco sold that year at the Henderson, North Carolina market. By the mid-1890s, tobacco challenged cotton as the primary cash crop throughout the Coastal Plain.

Tobacco production in the eastern Coastal Plain increased as farmers and others working in agricultural occupations balked at the persistence of five-cent cotton. When the price of cotton dipped to 4.59 cents per pound in 1894, officials of the Atlantic Coast Line Railroad launched a campaign urging farmers to plant more tobacco. The railroad's managers published supportive editorials in the *Southern Tobacco Journal* and distributed twenty thousand copies of a pamphlet titled, "The Tobacco Planter's Guide for Novice Growers of the Crop." Soon residents of eastern North Carolina towns joined in the tobacco boom by raising the crop on small plots just beyond the municipal limits. Noting that a local saloon owner planted twelve acres of tobacco just outside of town, the *Rocky Mount Argonaut* observed, "No difference what a man is occupied in, in Rocky Mount, he can't keep out of tobacco, for it is too good a thing."

As part of the campaign by Dixie businessmen to forge a New South in the late nineteenth century, urban merchants and boosters played a crucial role in the rise of tobacco in the eastern North Carolina countryside. In Lenoir County, for example, farmers followed the lead of Kinston entrepreneur Jesse W. Grainger. As county commissioner, first president of the local board of trade, chief executive officer of the Atlantic and North Carolina Railroad, president of the State Mutual Life Insurance Company, Lenoir County representative to the North Carolina General Assembly and delegate to two Democratic National Conventions, Grainger was widely recognized as the town's wealthiest and most influential businessman. Concerned about declining prices for Lenoir County agricultural products, he argued that defeating the mounting agricultural depression required introducing the crop that was becoming popular in neighboring Nash and Pitt Counties. In early 1885, he purchased $500 worth of tobacco seeds, distributed them to area farmers for free and promised to construct a warehouse in time for storage of the fall harvest. In later years, Grainger built additional warehouses in Kinston and successfully negotiated with James B. Duke's American Tobacco Company and the British-owned Imperial Tobacco Company to build local tobacco storage facilities.

In Rocky Mount, a community historically and inextricably tied to the Cotton Kingdom, the shift to tobacco proceeded equally as rapidly. Even the owners of the Rocky Mount Mills, the second oldest cotton mill in the state, assented to the expansion of tobacco culture. Thomas H. Battle, manager of the mill and scion of Rocky Mount's most influential family, looked askance at the tobacco men streaming into the Coastal Plain, calling them "men who have been successful elsewhere, who have, maybe, loose business principles, and no means." Battle no doubt expressed many elites' distaste for grasping men on the make who came from a different location and social class, but he nevertheless supported the arrival of tobacco. Under his direction, the Rocky Mount Mills, and the local bank (which his family controlled), invested heavily in tobacco-marketing enterprises.

In Wilson, the leading cotton merchant similarly abetted the shift to tobacco. Alpheus Branch operated a small bank in Halifax County before moving to Wilson after the Civil War and opening a cotton brokerage firm. Branch prospered, noted a contemporary, "by paying Wilson farmers too little for their cotton and charging them too much for fatback and fertilizer." In 1872, he and local attorney Thomas Jefferson Hadley founded Branch and Hadley, which later became the Branch Banking Company. Eventually, the firm became the Branch Bank and Trust (BB&T) Company, one of the leading financial institutions in the region. Branch continued to invest in cotton, but he also underwrote the growth of the tobacco industry in Wilson by lending money to farmers and local entrepreneurs for the construction and remodeling of warehouses.

Newspapermen in the four towns likewise jumped on the tobacco bandwagon, exhorting farmers to forsake cotton for the crop that they guaranteed would bring a new era of prosperity to the region. In doing so, they followed the lead of Southern journalists such as Henry W. Grady of the *Atlanta Constitution*, Henry Watterson of the *Louisville Courier-Journal*, Francis W. Dawson for the *Charleston News and Courier* and Richard H. Edmonds of the *Manufacturer's Record*, who preached the gospel of a New South. *Wilson Advance* editor Josephus Daniels, who later became the publisher of the *Raleigh News and Observer* and the secretary of the navy under Woodrow Wilson, began touting the virtues of tobacco cultivation in the early 1880s. Wary of local farmers' dependence upon a single money crop, he urged the cultivation of a few acres of tobacco on each farm as a hedge against plummeting cotton prices. Increasingly convinced of tobacco's viability in Eastern soils, he printed stores reporting the encouraging yields of those who devoted more acres to the crop. Initially, many Wilson merchants disputed Daniels's claims, warning against the rejection of a proven commodity and characterizing the turn to tobacco as needlessly risky. However, the successes of Wilson County farmers vindicated the newspaperman's arguments, and tobacco acreage increased throughout the region. Even after Daniels had departed for Raleigh, local boosters continued to echo his call for more tobacco. In 1890, the Wilson City Commission promised free land downtown and a five-year moratorium on tax assessments to anyone who built a tobacco warehouse or factory. "Bestir yourselves, men of Wilson," exhorted the *Wilson Mirror* that year, "and don't let the ball quit moving!"

Daniels's early efforts paled in comparison to the tobacco crusade spearheaded by David Whichard, editor and publisher of the *Greenville Daily Reflector*. Part owner at age

fifteen of the *Greenville Express*, which became the *Eastern Reflector* in 1882, Whichard quickly emerged as one of the community's most prominent citizens, serving as clerk to the board of aldermen, president of the local chamber of commerce and president of the North Carolina Press Association. Citing the success of farmers in neighboring counties, Whichard argued that Pitt County persistently suffered from a sluggish economy. He began publishing a regular report on tobacco in the *Daily Reflector* (newspapers in neighboring towns quickly copied this innovation) and arranged for veteran tobacco growers from outside the region to hold workshops and demonstrations in Greenville. "There is no reason why tobacco cannot be successfully grown here as anywhere else," he contended. Whichard continued, "Our soil and climate are adapted to the growth of the finest tobaccos, and we desire to see tobacco growing all over our county in a few years."

Once tobacco cultivation increased appreciably, Whichard decried the fact that eastern North Carolina farmers regularly shipped railroad carloads of tobacco to market in the Piedmont. In 1890, the opening of a new branch of the Wilmington and Weldon Railroad, which ran from Halifax to Kinston via Scotland Neck and Greenville, only enhanced the town's attractiveness as a regional marketing center. Whichard asserted that exporting crops to warehouses in Oxford and Henderson simply cost Greenville businessmen money, and he stated, "There is no reason why this town could not be made one of the best tobacco markets in the State." The *Eastern Reflector* contained blank forms on which farmers could detail the number of acres of tobacco they were planting. Whichard collected the forms and submitted the information to buyers as proof that the increasing amounts of tobacco grown in Pitt County merited the construction of warehouses and other storage facilities in Greenville. Meanwhile, the relentless editor urged local businessmen to pool their resources and build the warehouses that he argued the town desperately needed.

In 1891, a consortium of local businessmen heeded Whichard's call and opened the town's first tobacco warehouse. The Greenville Tobacco Warehouse handled over two million pounds of the crop that year, and Whichard reasoned that increasing productivity called for the construction of even more facilities. A second warehouse, the Eastern Tobacco Warehouse, opened for business in 1892, during which time area farmers sold more than one million pounds of tobacco in Greenville. The Planters Warehouse and the Star Warehouse opened in short order, and tobacco sales in the town surpassed 3.25 million pounds. Local businessmen organized the Greenville Tobacco Board of Trade that same year, recognizing the need to regulate the growing industry. By the end of the 1890s, Greenville's four warehouses handled millions of pounds of tobacco annually, and the town's boosters proudly boasted of their ranking as the second-busiest tobacco market in the New Bright Belt. With its 500,940 square feet of floor space, Farmers' Warehouse became the largest tobacco marketing facility in the world when it opened in 1904.

By the turn of the twentieth century, Wilson was the most lucrative tobacco market in eastern North Carolina. In 1890, the lone warehouse in town handled over 1.5 million pounds of tobacco, and by 1900, more than fifteen million pounds of the crop passed

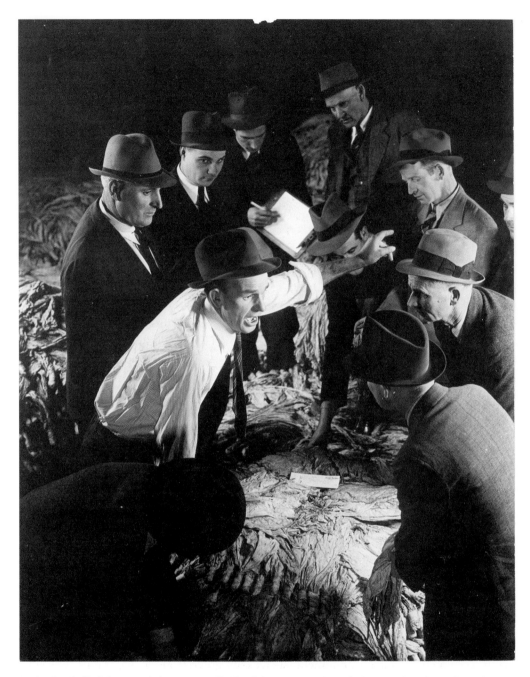

In the first half of the twentieth century, officials of the auction sale took their work as seriously as those who go to the office every day. They all came to the warehouse dressed in an "executive" manner because that's what they were…tobacco executives! Note the suits, hats and ties that all are wearing.

through the town's five warehouses. Cigarette consumption rose dramatically by the time of the First World War. Wartime scarcity drove tobacco prices to new heights, and eastern North Carolina farmers prospered as never before. More than forty-two million pounds of tobacco changed hands annually in ten Wilson warehouses containing a total floor space exceeding seven hundred thousand square feet. The North Carolina town surpassed Danville, Virginia, as the nation's preeminent flue-cured tobacco market—a position that Wilson retained, with only a brief interruption, for the remainder of the twentieth century.

While they grudgingly acknowledged superior sales in the Wilson and Greenville markets, tobacconists in Kinston and Rocky Mount hastily constructed their own warehouses to compete in the tobacco business. The opening of the Atlantic Warehouse, so-called because its owner claimed that it stood closer to the Atlantic Ocean than any of its competitors in eastern North Carolina, preceded the construction of several other warehouses in Kinston. The Rocky Mount Warehouse opened in 1887, and four warehouses in the community handled more than seven million pounds of tobacco by 1895. The rapid construction of warehouses in all of the towns signaled the arrival of a new commercial activity and, local businessmen hoped, a panacea for the recent economic doldrums.

Warehouse owners recognized that their profits increased in direct proportion to the number of farmers who sold their crops at auction, and the communities' competition for tobacco became fierce. The solicitation of business intensified in the summer as the fall harvest approached, but the drive to recruit and retain customers proceeded year-round. Because prices varied little from location to location, warehouse owners hoped to forge long-lasting bonds with the farmers by providing modern facilities, efficient service, congenial staffs and, above all, the impression of fair treatment. Warehouse employees scoured the region, staying in touch with longtime clients and distributing leaflets to potential patrons at funerals, picnics, county fairs, fish fries and religious revivals. Travelers in eastern North Carolina reported seeing tobacco warehouse signs affixed to fence posts and painted on barn roofs alongside ubiquitous advertisements for various brands of chewing tobacco. As Jonathan Daniels reported, "On all the highways are huge billboards advising the farmer to sell his tobacco in the Suchandsuch tobacco market which always gives a square deal and high prices."

Before automobiles and trucks allowed for decentralization within urban areas, tobacconists built warehouses in or adjacent to downtown areas and near railroad tracks. The massive warehouses dwarfed their surroundings. Frequently covering entire city blocks, these structures dominated small communities' central business districts, areas that housed diners, retail establishments such as dry goods stores and (occasionally) a few small factories. Constructed of wood, brick or corrugated iron, the warehouse possessed steeply pitched roofs to combat the torrential downpours common to the region. Covered driveways allowed farmers and warehouse employees to load and unload the tobacco safe from the sun and rain. On the insides of the warehouses, only an occasional pillar interrupted the cavernous dirt floor space where tobacco auctions proceeded each autumn. A few offices, livery stables and crude overnight accommodations for farmers lined the periphery of the building. Large skylights and windows provided the sunlight

necessary for buyers to assess the color of the tobacco leaves carefully. (Tobacconists thought artificial lighting inadequate, if not misleading, for grading the leaves.)

Farmers rose early in the morning, usually well before dawn, to transport their crops to tobacco towns and seek payoff for their labor. Like carnival barkers, doormen at the warehouses beckoned farmers to choose their establishment. Business began when African American laborers transferred the "hands" of tobacco from wagons or trucks to special wheelbarrows, weighed and arranged the bundles by grade on baskets and then placed them in rows on the floor under the watchful eyes of the white warehousemen. Tags affixed to each pile of tobacco identified its weight and the name of its seller. Farmers strolled around the warehouse, perusing piles of tobacco, trading stories with friends and acquaintances and discussing prices for crops sold weeks earlier in South Carolina and Georgia markets. As the floor filled with people and produce, warehouse proprietors greeted old customers by name and worked the room in the fashion of small-town politicians ingratiating themselves with voters. According to keen observers of small-town Southern life, the excitement prior to an auction resembled the air of anticipation on the county courthouse steps before the final tally of an election.

At a designated time, the auctioneer, exporters, buyers from the major domestic tobacco manufacturers and "pinhookers" (speculators who purchased the leaves for resale) commenced their march along the rows of tobacco. Buyers represented giant manufacturing firms such as the American Tobacco Company, Imperial Tobacco Company, R.J. Reynolds Tobacco Company, Liggett and Myers Tobacco Company, Universal Leaf Tobacco Company, Export Tobacco Company and Dibrell Brothers Tobacco Company. Corporate buyers and pinhookers stared intently at the piles of tobacco, often leaning forward to finger and smell the leaves. Having already assayed the color and weight of each pile of tobacco, the warehouse owner related an appropriate starting price to the auctioneer. Buyers seldom spoke during the auctions and instead conveyed their bids with a wink, a nod or a raised eyebrow. Bidding for most piles of tobacco lasted no more then ten or fifteen seconds, thereby allowing veteran auctioneers to complete hundreds of sales in a day. Auctioneers adopted distinctive styles, their nearly indecipherable chants seeming like so much gibberish to those unfamiliar with industry jargon. Appreciative crowds often gathered to view the spectacle, and warehouse owners sought to attract customers by employing flamboyant auctioneers widely known for their showmanship.

Revered like "local gods," notes historian Pete Daniel, "auctioneers were the aristocrats of the tobacco warehouse culture." Expectant farmers huddled behind the buyers, watching and listening to determine the price brought by their piles. If displeased with the price for a pile of tobacco, farmers could refuse payment by "turning the ticket" (turning the tag face down on the tobacco or tearing off a piece of it) and either request inclusion in a later auction or take their product to another warehouse. If satisfied, farmers received a check within a matter of minutes. The check deducted a 10 percent per hundred-pound weighing fee, auctioneers' charges (fifteen cents if less than one hundred pounds; twenty-five cents if more) and the warehousemen's commissions of 2.5 percent of the total sale price. The farmer then left for home or remained in town to celebrate the successful conclusion of another year's labor.

"Tobacco Towns: Urban Growth and Economic Development"

Farmers realized that selling tobacco in warehouses worked to the manufacturers' benefit and not their own. In a study of the South Carolina tobacco industry, where conditions were the same as in North Carolina, Eldred E. Prince Jr. concludes that "the tobacco auction system was the very essence of a buyers' market." At the mercy of market forces that nudged prices up and down each year and unable to determine what grade of tobacco buyers would seek at any given time, farmers could only haul their product to the warehouse and hope for the best. They could count on the warehousemen, who received a flat percentage of the final bid for their commissions, to urge generous prices. But the final result of sales depended upon buyers. Moreover, although farmers could always refuse bids they considered too low, a number of factors usually kept them from doing so. The farmers paid fees for each auction and had no desire to pay for lodging to remain in town and gamble on higher bids another day. Returning home with unsold tobacco meant running the risk of spoilage, an especially daunting prospect for the farmers who had conveyed crops to market at what they judged the most propitious time. In the vast majority of cases, therefore, resigned acceptance seemed the best course of action in the face of a disappointingly low bid.

After farmers received payment, they cashed their checks at nearby banks and settled their debts with creditors. Having used their crops as security earlier that year, they obtained credit from time merchants who typically charge annual interest rates of 25 percent. Tenants and sharecroppers usually paid their landlords, who waited eagerly inside the bank, before seeking out the doctors, lawyers, time merchants, fertilizer salesmen, agricultural implements dealers, used car salesmen and other local businessmen to whom they owed money. Tenants commonly surrendered at least three-fourths of their payment to landlords, time merchants and other creditors before concluding the day's business. If wives and children accompanied the farmers, the families probably went shopping downtown before heading home. If the farmers came alone, they likely remained in town to sample various leisure activities. After running a gauntlet of creditors and enjoying themselves for a night or two, few tenants and sharecroppers left town with much cash in their pocket or positive balances in the bankbooks.

Warehouses became the epicenters of the communities during harvest season, which lasted from August to early November of each year. Local residents noticed increased activity in town as the first farmers brought their crops to market (by wagon in the nineteenth century and increasingly by truck in the twentieth), and even those residents who lived some distance from the warehouse district detected the telltale smell of freshly cured tobacco when wagonloads of the crop rolled into town. Each community staged parades and other elaborate celebrations to commemorate the selling season. The annual festival in Wilson featured a contest to select champion amateur and professional auctioneers. Judges evaluated contestants in categories such as "intelligibility," "eye action" and "hand action." Beginning in 1898, the local chamber of commerce staged the Greenville Tobacco Fair every November. A parade with horse-drawn floats, marching bands and Spanish-American War veterans wound through the cheering crowds downtown. At the Pitt County Fairgrounds, crowds witnessed horse races and visited a stock pavilion and displays of manufactured items and farm produce at an

exhibit hall. At the fair's midway, spectators ogled exotic dancers, "the Turtle Boy, one of the greatest curiosities of the 19th Century" and other novelties. During the Depression, many tobacco towns sponsored beauty contests featuring "tobacco queens."

The most spectacular annual tobacco celebration occurred in Rocky Mount under the sponsorship of the Carolina Cotillion Club. The June German Festival, a black-tie affair for ten thousand invited guests, attracted revelers from a hundred-mile radius in eastern North Carolina. Jonathan Daniels called the affair "the first social event of the tobacco country, the biggest dance in the state, maybe in America—probably in the world," and stated, "It proves, undoubtedly, that there are 4,000 men with tuxedos and tails in the cash-crop tenant farmer land." Through the decades, the live music performed changed from classical to ragtime to jazz and swing. Nationally famous bands under the direction of Paul Tremaine, Ozzie Nelson, Jimmy Dorsey, Harold Stern and Rocky Mount native Kay Kyser headlined the all-night affair. Fittingly, Carolina Cotillion Club members converted the vast interior of a tobacco warehouse into a ballroom for the occasion. The extravagance of the celebration underscored the importance of tobacco to the community and the region.

Other businesses prospered, catering to the needs of outsiders in town at harvest time. Banks hired extra tellers and extended their business hours to accommodate the farmers, buyers and warehousemen who needed cash for warehouse transactions. Retailers stocked their shelves to capacity during the fall and reduced orders at other times of the year. Used-car lots filled in August and emptied in December. Local entrepreneurs operated hogshead factories in the shadows of the warehouses and sold their goods to tobacco buyers. Peddlers hawked apples, razor blades, patent medicine and other items on the streets alongside beggars, swindlers, confidence men and armed thieves seeking farmers' newly acquired wealth. In their quest to save souls, sidewalk preachers urged farmers to go back home and forego the leisure activities offered near the warehouse district. Taverns abounded in the four tobacco towns at a time when all but a few counties in North Carolina remained dry. In turn-of-the-century Greenville, for example, saloons outnumbered churches thirteen to nine. When his crusade brought him to town in 1902, famed evangelist Sam Jones excoriated the citizenry for this scandalous situation. The "better element" of the tobacco towns also groused about increased activity in the local red light districts, the existence of which local clergymen attributed to the pernicious effects of the tobacco trade. Kinston's "Sugar Hill" attained special notoriety for its vice offerings, but prostitution thrived in neighborhoods near the warehouses in all the tobacco towns.

Hotbeds of activity for a few months each autumn, giant tobacco warehouses stood empty for the rest of the year. From January through July, most of the men employed there worked at filling stations, performed odd jobs around town or prepared seedbeds at their own farms. Warehousemen worked frenetically during the harvest season and did very little at other times, proudly proclaiming the following motto: "work like hell, drink like hell, and loaf like hell." Eager to make any money they could during the off-season, warehouse owners rented the space for storage of fertilizer, agricultural goods and farm machinery, as well as for any other purposes they could conceive. Tobacco warehouses

served as venues for cotillions, boxing matches, political rallies, farm machinery expositions, high school graduations and formals, reunions of Civil War veterans and other special events.

While giant manufacturers such as the American Tobacco Company and the Imperial Tobacco Company occasionally built prizeries and drying houses in eastern North Carolina tobacco towns, local businessmen frequently owned and operated these facilities and auction warehouses. These entrepreneurs, almost all of whom moved to tobacco towns from the surrounding countryside or from Virginia and the North Carolina Piedmont in the late nineteenth and early twentieth centuries, parlayed their familiarity with tobacco culture into leadership roles in their adopted communities. They were either tobacco farmers seeking to increase their profits by controlling another stage of production or veteran warehousemen from the Old Belt who believed their expertise

Left to right: Legendary auctioneer Pete Sermons grinds the prices out at New Independent Tobacco Warehouse, Greenville, North Carolina, while warehouseman "Sonny" Belcher leads the buyers down row after row of golden leaf. (October 1974.)

could be lucrative in the development of the New Belt. These businessmen constituted an elite class whose wealth and prestige allowed them to dominate political and social life in the tobacco towns of eastern North Carolina. They held the majority of the seats in local chambers of commerce and boards of trade, occupied the key electoral positions in municipal government, worshipped together in the same churches, vacationed at the same beaches along North Carolina's Atlantic coastline and lived in the communities' most exclusive neighborhoods. The leading tobacconists built ornate mansions along Caswell, Queen, Gordon and Washington Streets in Kinston and in the Skinnerville neighborhood west of Evans Street in Greenville. Their counterparts in Wilson resided on West Nash Street, a tree-lined boulevard that Jonathan Daniels called "one of the four or five loveliest streets in the South." Philanthropic tobacconists also donated considerable sums of money for the construction of public libraries, hospitals and other semipublic institutions.

A prototype of the young man on the make who prospered in eastern North Carolina, Edward Bancroft ("E.B.")Ficklen started in the tobacco business in Danville, Virginia, and relocated to Greenville in the 1890s to be a commission buyer for a large firm. In 1896, he formed the E.B. Ficklin Tobacco Company and served as its president until his death in 1925. James S. Ficklin succeeded his father and directed the company's steady expansion for the next thirty years. Unlike the family patriarch, who kept a low public profile and shied away from extensive involvement in local affairs, Ficklin *fils* (personified the) tobacco scene. President of the Greenville Tobacco Board of Trade and chief executive officer of Wachovia Bank and Trust Company of Winston-Salem, he was elected president of the Tobacco Association of the United States, the industry's most important trade association. Louis Ficklin, the patriarch's youngest son, managed the business from 1955 to 1963, when he engineered a merger with three other firms to form Carolina Leaf Tobacco Company, the region's largest. The Ficklin family became the benefactors of East Carolina Teachers College, which later became East Carolina University, and underwrote the construction of the football stadium, as well as some of the academic buildings on campus.

A native of Oxford, North Carolina, in the heart of the Old Bright Tobacco Belt, Ula "Dick" Cozart graduated from Horner's Military Institute and then entered the warehouse business with his father in Oxford. In 1891, he came to Wilson and worked for a local tobacco company. After operating a warehouse in Durham for a year, Cozart returned to Wilson in 1893 and opened the Centre Brick Warehouse with Captain Tom Washington, another newcomer to Wilson.

One of the founders of the Wilson Tobacco Market, a local trade association, Cozart also served as a lifetime member of the U.S. Tobacco Association's board of governors. A director of the National Bank of Wilson, he served for twelve years as a town alderman and a trustee of the Wilson City Schools. Like so many other newcomers to eastern North Carolina towns, he used his capital, entrepreneurial skills and knowledge of tobacco culture to acquire great wealth, marry into the local gentry and firmly establish himself as a leading man in the rapidly changing New South landscape.

The tobacconists of eastern North Carolina prospered as economic middlemen between producers and industrialists. Similarly, the region's marketing centers thrived

as the key locations where farmers sold their crops and middlemen prepared them for shipment to larger manufacturing centers. Content with performing a discrete function in the production of tobacco products, local businessmen seldom challenged the giant corporations that dominated the cigarette industry. The Wells-Whitehead Tobacco Company of Wilson, incorporated in 1900, enjoyed some success producing Caroline Bright cigarettes until the American Tobacco Company acquired it in 1903 and moved all of its machinery to Durham. Two other Wilson companies—the Ware-Kramer Tobacco Company, which manufactured White Roll cigarettes, and the Erwin-Nadal Tobacco Company, which made Contentnea and Plan cigarettes—enjoyed modest sales prior to going out of business before the First World War. For the most part, businessmen in the eastern North Carolina tobacco towns quickly recognized the futility of competing with long-established cigarette manufacturers and accepted their limited but highly profitable role in the industry.

Tobacco provided a livelihood for hundreds of African Americans who occupied the opposite end of the social order in Wilson, Kinston, Greenville and Rocky Mount. From the auction warehouses to the stemmeries and prizeries to the re-drying houses, black men and women typically worked ten-hour days, five and a half days a week for rock-bottom wages. Believing that sunlight and fresh air would dry out the tobacco, white supervisors in stemmeries closed and covered windows. Consequently, workers often tied handkerchiefs over their noses to keep from inhaling the stagnant air. Because of the extreme heat, the noisome odor permeating the cramped quarters, the tobacco dust filling the air and the extremely low wages paid for mind-numbing piecework, stemmeries attracted only unskilled workers who could find no other employment. A few black men worked there, but samples of U.S. Census records indicate that more than 90 percent of the workers were women—an important exception to the Jim Crow prohibition throughout much of the South against hiring African American women for industrial jobs. (The Rocky Mount Mills, one of the largest employers in the region, hired only white women.) Some African American women, who were unable to work all day in factories, graded tobacco leaves in their homes. Census records fail to reflect accurately the number of children who worked as stemmers, mostly alongside their mothers on disassembly lines. However, oral histories and photographs document these youngsters' presence. White supervisors commonly forbade talking on the shop floor but allowed the workers to sing. Although factory owners interpreted workers' singing as evidence of the contentment, surviving accounts of African American workers emphasize the extremely unpleasant and unhealthy conditions they endured in the sweltering factories.

Warehouse and factory owners employed a few of their workers as custodians or handymen throughout the year. But for the vast majority of African Americans, jobs were available in tobacco towns only from late summer to early winter. U.S. Census records, local directories and company payrolls indicate that many workers resided in tobacco towns temporarily, renting rooms (sometimes by the week) in boardinghouses or staying with relatives during the few months they worked in factories. They typically found lodging in the African American residential area near downtown, where they could easily walk to and from work. Many black members of the workforce drifted off

into the countryside during the winter to prepare for another cycle of tobacco cultivation as tenant farmers, sharecroppers or farm laborers. Having temporarily resided in town for seasonal work, they returned to family farms for the rest of the year. Many African Americans traveled to Northern cities looking for work in the winter months. In Rocky Mount, for example, blacks often went to Washington, D.C., in search of temporary employment. Many black tobacco workers tended the leaves twelve months a year, whether in the countryside or in town.

Federal Writers' Project interviews conducted with veteran tobacco workers in eastern North Carolina during the 1930s capture the economic uncertainty and instability of their transient lives. Wilson tobacco packer William Batts dug ditches, sawed wood and performed other odd jobs after the factories closed in the winter. He farmed in the spring and summer before returning to town in the fall, and his wife worked in a stemmery. "I didn't like de work in de warehouse," he confided to an interviewer. Batts added, "De scent of the tobacco was so strong that it made me sick, even if I was raised with it, and I've spent my whole life around here and you can imagine that I'm used to de stuff." W.H. Etheridge, a stemmery worker in Wilson, recounted that he worked full time during the tobacco season but only earned approximately $600. The rest of the year, he remained idle. "If this town had as much doing all year as it does in the fall," he lamented, "we could all of us get a little something to do and life would be worth living." After explaining that he enjoyed the work and only regretted its impermanence, Etheridge recanted and said, "I say it suits me alright. That is not entirely true. There is no future to it. Everything it pays is required for living expenses, and it's a poor living at best."

Some African Americans who permanently resided in the tobacco towns alternated work in warehouses and factories during the autumn with work in the tobacco fields during the other season. Each day, scores of African American men congregated at designated street corners early in the mornings until white farmers came by, loaded as many laborers as they could use into wagons or trucks, transported them to their farms and brought them back to town in the evening. "So go down to the street early 'n the morning," recalled a black resident of Wilson, "you'd see old and young blacks just sitting on the corner waiting for the truck to come by to pick them up." Farm workers sat on street corners alongside black women, many of whom toiled during the tobacco season as stemmers, who waited for well-to-do white women to drive by and select them for domestic work as maids, cooks, laundresses and the like.

Black tobacco workers who remained in the towns year-round lived in African American communities that Jim Crow statues and customs rigidly segregated from white residential neighborhoods. After whites had expropriated the better house building sites in these communities, blacks could only gravitate toward the low-lying, poorly drained area "on the other side of the tracks" near downtown. African American laborers lived in substandard housing, usually in one-room shacks and tiny duplexes. Shotgun houses, consisting of two or three rooms arranged in a straight line from front to back on narrow lots, served as low-rent tenements by the 1910s. Wealthy whites frequently invested in real estate in the densely populated African American enclaves, renting rooms and

"Tobacco Towns: Urban Growth and Economic Development"

houses to black workers and families. Yet some African American professionals managed to acquire property. During the late nineteenth and early twentieth centuries, a steady flow of rural black migrants arrived in eastern North Carolina towns seeking work in the tobacco industry and found lodging in neighborhoods such as East Wilson, West Greenville, Crosstown and Happy Hill in Rocky Mount.

Confined to discrete areas of the towns in which they lived, African Americans formed mixed-class communities. The majority of blacks worked in tobacco warehouses and factories and as day laborers, barbers, teamsters, draymen and domestics. Teachers, clergymen, medical professionals, shopkeepers and other businessmen formed the African American middle class. In Wilson, for example, real estate investor Samuel H. Vick, physician Frank Hargrove, undertaker Charles Darden and contractor Oliver Freeman became the most prominent members of a black professional class that founded a number of successful mutual-aid, life insurance and burial societies, as well as fraternal orders such as the Masons, Elks and Odd Fellows. Vick developed Vicksburg Manor and other residential neighborhoods with small but well-appointed houses for the working class. Hargrove succeeded in founding Mercy Hospital, one of the first black hospitals in North Carolina, and Darden's unrelenting efforts resulted in the opening of Charles H. Darden High School for African Americans. These men built spacious homes on East Green Street that failed to rival the mansions of the white elite on West Nash Street but nevertheless set a standard for middle-class respectability in Wilson's black community.

Although little capital was available for the operation of large-scale enterprises, African Americans managed to operate small businesses within their communities. Black residents of the tobacco towns patronized African American–owned cafes, theaters, barbershops, funeral parlors, insurances companies, dry cleaners, grocery stores, beauty salons and pool halls. A few black physicians, dentists and undertakers provided essential services. Small business districts for African Americans existed apart from the tobacco town's comparatively large central business districts. In Wilson, for example, a cluster of black-owned businesses thrived on East Nash Street, separated from the white downtown by the railroad tracks. Two blocks long and about one-sixth the size of the principal shopping area to the west, Wilson's black commercial and entertainment center contained a handful of modest one- and two-story wooden buildings. Greenville's black downtown spanned several blocks on Albemarle Avenue, adjacent to the railroad tracks that formed the western boundary of the town's central business district. "The Block," a portion of Albemarle Avenue that attracted throngs of black revelers from around the region on the weekends, contained nightclubs, oyster bars, dance halls and the Plaza Theater. The black business district in Rocky Mount, which extended several blocks east of the railroad tracks paralleling Main Street, contained diners, barbershops, shoe stores, medical and dental offices, a mortuary, a pool hall, a photography studio and a branch office of the Durham-based North Carolina Mutual Life Insurance Company.

Vitality in black and white downtowns resulted from increased economic activity generated by the arrival of tobacco in the late nineteenth century. Within a generation, struggling towns in an impoverished region of North Carolina became thriving, bustling

communities that enjoyed unprecedented growth and development. Urban boosters and businessmen played a leading role in introducing tobacco to the countryside; large landowners invested in tobacco warehouses and other facilities; and African American laborers moved regularly between farms and factories. The line between the marketing centers and the countryside blurred. Warehousemen and factory owners arranged their schedules to fit the seasonal tasks of tobacco cultivation, as did others living in Greenville, Wilson, Kinston and Rocky Mount. By the time of the First World War, the residents of these communities proudly proclaimed that they lived in urban places clearly defined as tobacco towns.

In the years following the Second World War, mechanization altered the tobacco business in factories and farms, creating important consequences for tobacco towns. Just as the introduction of mechanical harvesters and other laborsaving farm machinery forced small landowners out of business and ushered in a new era dominated by large agribusiness firms, the widespread adoption of new technology in stemmeries and re-drying plants reduced the tobacco industry's seasonal labor needs. The 1964 Surgeon General's report linked tobacco use with cancer, thereby eroding confidence in the long-range prospects of tobacco farming and convincing some landowners to plant other crops. Claiming the need for greater efficiency in shrinking domestic markets, U.S. tobacco companies began contracting directly with farmers and eliminating auction sales in the 1990s. The auction system declined rapidly, and only about 20 percent of the nation's tobacco crop was auctioned in 2001. Just a few tobacco warehouses in Wilson and none in eastern North Carolina's other tobacco towns remained open by the end of the twentieth century.

To offset the loss of employment opportunities, tobacco towns tried to attract new industries and diversify their economies. Their degrees of success varied widely, as evidenced by the contrasting situations of Kinston and Greenville. As late as 1960, Kinston remained the larger and more prosperous community, with 24,819 people to Greenville's 22,860. As tobacco sales fell precipitously thereafter, the Kinston Chamber of Commerce initiated a series of unsuccessful development schemes. The most spectacular Kinston failure, the Global Transpark Zone, lost millions of state and private dollars while failing to attract new businesses and a new regional airport. By the end of the twentieth century, Kinston's declining population, dying downtown, double-digit unemployment and numerous blocks of boarded-up houses made it eastern North Carolina's most conspicuous urban failure. Greenville, by contrast, enjoyed a period of rapid growth and expansion. Enrollment at East Carolina University exceeded 25,000 in 2003, and the university medical school combined with the local hospital to form the largest regional healthcare facility in the state east of Interstate 95. Pharmaceutical factories and other high-tech industries contributed to the boom. In 2000, Greenville's rising population of 60,476 dwarfed Kinston's steadily declining total of 23,688.

Greenville's ability to diversify its economy cushioned the blow as tobacco, once the lifeblood of the community, became less important to the local market. As in other tobacco towns, auction warehouses and factories still dotted the cityscape, and a handful of tobacco-related businesses remained, mostly as pale reminders of a past way

"Tobacco Towns: Urban Growth and Economic Development"

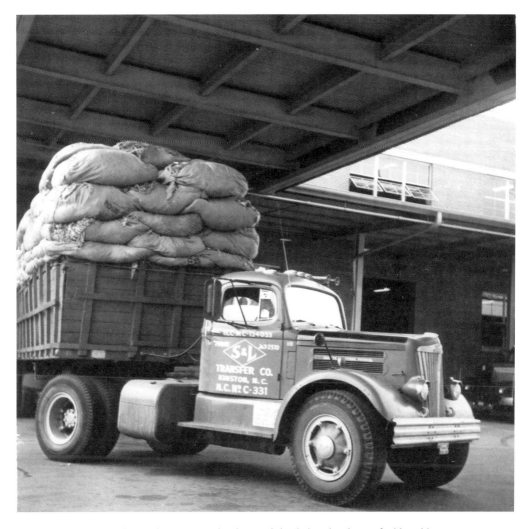

Leonard Basden, over-the-road transporter, has his truck loaded with tobacco freshly sold at auction in Kinston, North Carolina.

of life. A century earlier, as Southerners struggled to recover from the catastrophe of the Civil War, lay the economic foundations of a New South, reassert white supremacy and dominate an African American labor force, the rise of tobacco in eastern North Carolina gave new life to the towns of the region. Local tobacconists acting as economic middlemen in a burgeoning industry refashioned Wilson, Kinston, Greenville and Rocky Mount, as well as smaller nearby communities, into tobacco towns that grew rapidly and became the economic leaders of the state's inner Coastal Plain. No less significant than the rebirth of Birmingham, Atlanta, Durham and Winston-Salem, the transformation of these significant four North Carolina towns constitutes an important part of the New South's history.

North Carolina Tobacco

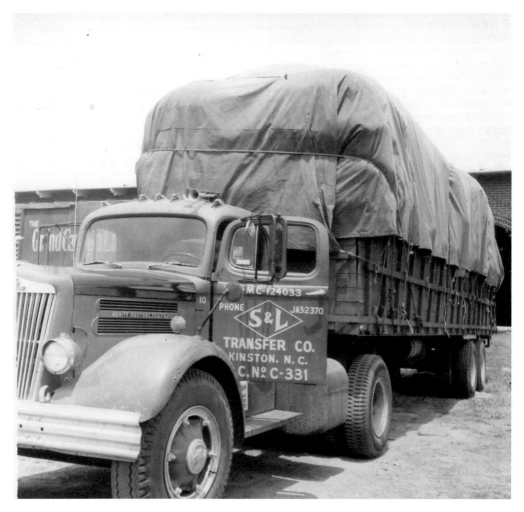

A truck loaded and ready to take tobacco to the processors in Richmond, Durham, Winston-Salem or wherever the plants might be located along the eastern seaboard.

Note: This article originally appeared in the April 2007 edition of the *North Carolina Historical Review* and is one of the most comprehensive interpretations found anywhere on eastern North Carolina tobacco culture. Written by Roger Biles, the essay provides a broad-based look at all social influences manifested in the phases of tobacco production, marketing and manufacturing. The *Review* graciously allowed me to reprint the article in this project.

Dr. Biles is a professor of history and department chair at Illinois State University. He would like to thank Lu Ann Jones and Maury York for their assistance in the preparation of this article.

"Fifty Years of Tobacco: How Did We Get to Where We Are?"

by John H. Cyrus

The present tobacco program as we know it today was born out of a crisis situation during the depths of the Great Depression in the early 1930s. It started with the enactment of the Emergency Agriculture Adjustment Act, which was passed on May 12, 1933. The following outline shows the advancement of the tobacco program down through the last fifty years.

1933: The Emergency Agriculture Adjustment Act (EAAA) provided that producers who voluntarily agreed to reduce production would receive compliance payments known as acreage rental and benefit payments. Because of the lateness of the enactment date, the voluntary production control was not implemented until 1943. However, a tax provided for in the act against tobacco processors of 4.2 cents per pound was started in 1933 to begin raising money for benefit payments for participating growers.

The EAAA established 1919–1929 as the parity base years for tobacco, and upon that base a fair exchange of seventeen cents per pound was established. Following low prices in 1933, approximately 95 percent of the flue-cured tobacco growers signed voluntary production control contracts in 1933 for the 1934 crop year.

The EAAA of 1933 was ruled unconstitutional by the U.S. Supreme Court in January 1936 because of the processing tax and other control features under the Kerr-Smith Act.

1934: The Kerr-Smith Act was passed in 1934 to reinforce the voluntary acreage control. This act provided that tobacco produced in excess of contract or without contract would be taxed at the rate of 25 percent of its sale price. Receipts would be used along with the processing tax to compensate growers who adjusted production.

1936: In February of 1936, Congress repealed the Kerr-Smith Act and passed the Soil Conservation and Domestic Allotment Act. This act authorized payments from appropriated funds for diverting acreage from soil-depleting crops, which included tobacco. Along with soil improvement practices, the major purpose was to reduce acreage so as to decrease supply. The results were higher prices for tobacco in 1936.

Three tobacconists (among other things) discussing tobacco's golden values, while delivering their products to Border Belt markets in Lumberton, North Carolina. *Left to right*: Billy Yeargin, agriculture aide to U.S. Senator Robert Morgan; John Cyrus, chief of Tobacco Affairs, North Carolina Department of Agriculture; and North Carolina Governor James B. Hunt Jr.

Because of the higher prices, controls were relaxed in 1937, which led to an 80 percent increase in burley tobacco and a 25 percent increase in flue-cured production. Thus, control problems in 1937 led to another change in the tobacco program.

1938: The Agricultural Adjustment Act of 1938 was passed early that year, which is the basis of the current tobacco program as amended. The AAA of 1938 provided for the continuation of the Soil Conservation and Domestic Allotment Act and also provided for the establishment of marketing quotas. However, acreage controls continued to be managed through contracts under the Soil Conservation and Domestic Allotment Section, which made payments to growers to divert tobacco acreage to soil building crop.

Quotas were proportioned among states according to past production and among farmers according to past marketings. Penalty for marketing in excess of quota would be 50 percent of the market price but not less than three cents per pound for flue-cured tobacco, and not less than two cents for other kinds. The AAA required that marketing quotas be approved each year by two-thirds of the producers.

"Fifty Years of Tobacco: How Did We Get to Where We Are?"

The 1980 market opening in Lumberton. *Left to right*: Billy Yeargin, agriculture aide to U.S. Senator Robert Morgan; "Mr. Tobacco," Furney Todd, tobacco specialist, North Carolina State University (NCSU); North Carolina Governor Jim Hunt; and Fred G. Bond, CEO, Flue-Cured Tobacco Stabilization Cooperative claim bragging rights to some of the finest tobacco in the world.

The AAA of 1938 authorized payments for the difference between parity price and market price. Funds for these payments were provided by appropriation rather than by a tax levy on processors and quota penalty. Loan rates were 75 percent of parity for flue-cured and burley, and direct payments were made in 1938 to bring tobacco prices up to 75 percent of parity. Quotas were rejected by producers in 1939.

1939: AAA of 1938 was amended in 1939. A 35 percent increase in flue-cured production with no quotas in 1939, plus the fact that Britain entered World War II in 1939, led to a major tobacco crisis. Flue-cured markets were closed in September of 1939 after British buyers pulled off the market. Thus, efforts to resolve the crisis resulted in the 1939 amendment, which provided for acreage allotments for the first time along with marketing quotas. With this change, quotas were announced for the 1940 flue-cured crop and approved by growers in a referendum. Burley growers also approved quotas for the 1940 crop under the amended 1938 act.

1941: The Burley Tobacco Association, which was originally chartered in 1921, was reactivated in 1941 to operate the burley loan program under an agreement with the CCC.

1942: The Price Control Act of 1942. This act included tobacco under price controls during World War II when tobacco was in short supply. A congressional resolution increased tobacco acreage allotments in 1944 by 25 percent, and an additional 10 percent in 1946 without regard to actual supply and reserve supply under the formula.

1946: The Flue-cured Tobacco Cooperative Stabilization Corporation was organized following World War II in 1946. This farmer cooperative performed the physical and financial management of the government price support plan, which established minimum prices based on government grades. Loans were advanced to growers on tobacco that failed to sell above the established support. These loans were financed through local banks acting as agents for the CCC, with the support level at 90 percent of parity.

1948: In 1948, the AAA of 1938 was amended to change the method of computing parity prices, by specifying that the parity price would reflect relative prices in the production of all farm commodities during the preceding ten-year period. It was amended again in 1949 to add wages to prices paid and to provide for a traditional parity, which moved to the modernized formula. The modernized parity was first applied to tobacco in 1950. The modernized parity was used for tobacco from 1950 through 1959.

1956: The Soil Bank Act of 1956 provided annual payments for retiring land from the production of tobacco and certain other soil depleting crops.

1960: In 1960, Congress enacted a law to freeze price supports at the 1959 level. This was in response to problems that developed with the modernized parity, coupled with the 90 percent of parity rate that was in effect from 1943 through 1959. This formula caused tobacco prices to rise more rapidly than the parity index and the prices of non-supported crops, which created concern because the U.S. share of the flue-cured export market was declining. Beginning in 1960, flue-cured price support was frozen at 55.5 cents per pound, and it is still frozen at that level under the present formula. Under the 1960 formula, the frozen price support of 55.5 cents per pound is multiplied by the ratio of the average of the index of prices paid by farmers for the three previous calendar years, to the index of prices paid for the 1959 calendar year.

1961: In 1961, Congress again amended the tobacco program through Public Law 87-10, which authorized the intracounty lease and transfer of flue-cured allotments with certain limitations.

1965: In 1965, Congress made another major amendment in the AAA of 1938 by authorizing the acreage-poundage quota program. This was necessary because growers were using new high yielding varieties and new technology with emphasis on tonnage per acre rather than quality. The deterioration in quality almost destroyed the foreign market for U.S. flue-cured tobacco.

A referendum was held in March 1965 and growers approved the change to an acreage-poundage program, which was implemented that same year even though Georgia and Florida had already started transplanting.

The acreage poundage program allowed a producer to sell 110 percent of his quota with adjustments each year for over-marketing and under-marketing to get his effective quota the following year.

1967: Beginning in 1962, through 1967, limited untied flue-cured sales were permitted in the Carolinas and Virginia by administrative action through regulations. In 1962 untied sales were authorized during the first five sales days for priming and lug grades

only. Beginning with the 1968 marketing season, presheeted flue-cured tobacco packed on the farm in standard ninety-six by ninety-six-inch burlap sheets was authorized through regulations throughout the season in the Carolinas and Virginia. (Growers in the Georgia-Florida area have traditionally sold flue-cured untied in burlap sheets through agreements with some buying companies, who encouraged an increase in the production of flue-cured tobacco in that area during the early 1920s, following the Tri-State Cooperative Marketing movement in the Carolinas and Virginia, which several exporting companies opposed.)

1971: In April of 1971, Public Law 92-10 amended the AAA of 1938 to provide for poundage quotas for burley tobacco in lieu of acreage allotments. Also, intracounty lease and transfer of burley tobacco quotas was approved by grower referendum in 1971.

1974: Through administrative actions in 1974, the grower designation of market plan was implemented to provide relief from congestion at many warehouses and to spread sales more uniformly throughout the season. This regulation required, as a condition of eligibility for price support, that producers designate in advance the warehouse where they desired to sell their tobacco. The secretary of agriculture also appointed a thirty-seven-man Flue-cured Tobacco Marketing Advisory Committee composed of twenty farmers, nine warehousemen and eight buying company representatives to advise him in marketing procedures and regulations.

1982: The no net cost Tobacco Program of 1982 provided further amendments to the AAA of 1938. The major provision of this amendment package, which was signed by the president on July 20, 1982, on the eve of the markets opening in the Georgia-Florida area, was to require (1) an assessment from producers to establish a capital fund to assure that the tobacco price support programs would be no cost to the government. Other changes in the 1982 amendments provided for (2) additional authority to the secretary of agriculture to further adjust price supports by supplying only 65 percent of any increase in the price support provided under the formula; (3) the requirement that allotments held by nonfarm corporations, institutions and certain other allotment holders where land is not managed for agricultural purposes be sold to qualified producers within the same county by December 1, 1983, or allotment will be forfeited; (4) farm owners with tobacco allotments to voluntarily sell their allotment to qualified active producers; (5) an established definition for an active producer eligible to buy or lease tobacco quotas; and (6) periodic adjustment if the national yield factor for flue-cured acreage-poundage quotas at five-year intervals, using the last five years moving average yield as a base.

1983: Another amendment to the AAA was enacted in July of 1983 to freeze the price support for the 1983 marketing season at the 1982 level for flue-cured and other types of tobacco under marketing quotas and price support. Flue-cured was frozen at $169.90 per hundred, and burley price support was frozen at $175.10 per hundred.

In November 1983 the AAA was again amended through the enactment of the "Dairy and Tobacco Adjustment Act of 1983." The major tobacco provisions of this act were as follows:

1.) Freeze flue-cured price support for 1984 and possibly 1985, if the formula does not show an increase in price support more than 5 percent in 1985. For other kinds of tobacco under marketing quotas, the support level would be established at such levels that would not narrow the price support differential between flue-cured and such other kinds of tobacco.

2.) Eliminates the no net cost assessment on owners of quotas at the time it is leased and transferred.

3.) Eliminates the lease and transfer program beginning in 1987.

4.) Gives the secretary authority to further reduce price supports on non-competitive grades representing up to 25 percent of crop by 12 percent, if requested by the load association board of directors.

5.) Provides that the lessee shall not pay the proceeds for leased quota until the tobacco is produced and sold, beginning in 1985.

6.) Date extended from December 1, 1983, to December 1, 1984, for mandatory sales of flue-cured and burley quotas held by nonfarm entities, and clarifies exemption from mandatory sales.

7.) Beginning in 1986, any quota that has not been grown on the farm assigned, or considered to have been grown on the farm assigned, two out of the last three years will be forfeited.

8.) Increases reserve from national quotas from 1 percent to 3 percent for adjustment in old allotments and new grower allotments, with 2 percent set aside for new growers.

9.) Requires the secretary to establish inspection for imported tobacco insofar as is practical, excluding oriental and cigar tobacco.

10.) Extends from December 1 to December 15 the date for the announcement of flue-cured quotas by the secretary.

11.) Requires the secretary to determine acreage of flue-cured tobacco planted on all farms.

Note: The Loan Support and Acreage Control Program was one of the most successful and lucrative arrangements between the American government and the people. Through it, tobacco farmers adhered to a formula that would maintain a demand-supply balance, which ultimately kept market prices at a profit level. Out of this arrangement, the U.S. government has netted billions of dollars in principal and interest, paid by tobacco farmers on loans during the life of the program.

John Cyrus, a well-respected figure in North Carolina's tobacco arena who served most of his career with the North Carolina Department of Agriculture as chief of Tobacco Affairs, offers an expert assessment on the origins and values of the Loan Support and Control Program. This program was initiated in 1933 by Roosevelt's New Deal. It was then altered and tailored several times over the ensuing thirteen years, and finally renovated in 1946 to become the fundamental ground rule of tobacco farming and marketing until its demise in 2004.

"Between You and Me"
by Carroll Leggett

North Carolina's tobacco markets are gone with the wind. It used to be that sitting here in Winston-Salem at this time of year, you could smell the musky odor of cured tobacco wafting across the city from the north side warehouse district.

On down the highway, Durham would be buzzing. Farmers with cash money in their overall pockets would be eating thick pork chops, mashed potatoes and gravy at the Acorn restaurant, drinking cheap whiskey and looking for fast women. I ate many a down-home meal at the Acorn years ago, but I have no personal observations to make, thank you, about cheap whiskey and fast women.

Farther east in Wilson—the world's largest flue-cured tobacco market—barbecue restaurants would be packed. Farmers with hearty appetites piled in ordering the "large" combination dinners, wolfing down chopped barbecue, fried chicken, boiled potatoes, Brunswick stew and hushpuppies. Tourists from Up North, with more delicate appetites, would stop and invariably order a barbecue sandwich. A usually reliable source tells me that waiters at the famous, original Parker's Restaurant in Wilson began referring to barbecue sandwiches as "Yankee dinners," and that today Parker's waiters still write "YD" when a customer orders a barbecue sandwich.

Fact or fiction? Ask the folks at Parker's on old 301.

Greenville had a flourishing market also, but the warehouses are empty now. Pitt County is still the state's largest producer of flue-cured tobacco, the *Daily Reflector* says (frankly, I thought it was Johnston), but according to my publisher friend Jordan Whichard's paper, "This year saw Pitt County without a warehouse or tobacco auction for the first time in a century."

Cavernous old Gold Leaf 525 warehouse down near Pirate Stadium grew silent a couple of years ago, and today a brand-new Eckerd's sits where Alfred Earl Garris and Wayne Dixon used to preside over a bustling auction house. My nephew Clay, who lives in Pitt County and is training to be an auctioneer, tells me he has to go to warehouses in Kinston and Williamston to hear the chants. Odds are against his ever selling any tobacco, though.

Most farmers are contracting directly with the tobacco companies now, selling their crops direct and bypassing the old auction system. I hate it like the devil—not just because local economies are taking a hit, but because a colorful bit of North Carolina tradition and folkways has "died suddenly," as the Down East obituaries often say.

There was always a profusion of hucksters at the market. Tommy Bunn, executive vice-president of the Leaf Tobacco Exporters Association, remembers particularly the "sock man." My brothers and I remember him also, because our grandfather—Papa as we called him—would buy socks from him and give them to us. They were the thin, light-colored, nylon variety with arrows that ran down the sides and ended at that knob called your ankle. We always thanked him, of course, and relegated them to what we called the "Papa drawer" that contained items he had given us that no kin in his right mind would ever think of wearing.

The sock man hawked out of the boot of his car. Tommy remembers him saying, "Socks, socks. Buy yourself some socks. Don't like the color? Take'm home and washum! Money-back guarantee. Bringum back…I guarantee you won't find me!" I remember seeing farmers sitting around the filling station in the fall wearing the sock man's socks. They were so thin the hairs on the old guys' legs would pop right though—looking like some sort of strange, nylon-covered Chia Pet.

Rawleigh products salesmen who traveled country roads all during the year selling salve and flavoring and liniment would set up shop in the parking lots. And one year Papa came home with a chenille bedspread with a colorful—and I do mean "colorful"—peacock design like the ones you see hanging on clotheslines in Appalachia. Fact was, hard money—the first they had seen in months—would burn a hole in a farmer's pocket, and the hucksters were there to relieve him of some of it.

Martin Lancaster, president of North Carolina Community College System, reminded me recently that his father owned the old Liberty Warehouse in Wilson. He had to sell it in 1976 because of declining health.

Good warehousemen like Mr. Lancaster cultivated their clientele and made sure the best farmers—those who grew quality leaf and cured it to perfection—sold their tobacco with them. During the off season they would ride about the countryside, drive up the lanes to the big houses and sip a glass of iced tea on the porch. They made sure those farmers had tobacco on the floor the day the market opened to drive up the opening-day average that was broadcast on every farm show in the state.

One of the most famous radio personalities Down East was W.E. Debnam, father of Mini Page creator, Betty Debnam. His program was sponsored by Smith Douglass Fertilizer and began with the words, "Debnam views the news. SD on your fertilizer bag means 'square deal.'" Mr. Debnam gave the farm news at noon, of course, when farmers went to the house for "dinner." The average sales price of tobacco on the major markets was reported religiously.

The game, of course, was to get the highest dollar for your tobacco. Some farmers sold with the same warehouse for decades, knowing that the owner would see they got a fair price from the company buyers. If bidding was too low, "the house" would buy the tobacco and put it back on the floor the next day. Others farmers shopped around,

listening to reports filtering back home about which warehouses were getting farmers the highest prices.

A friend of mine's mother, who was widowed young, would take him and his brother and sister to the market and stand with them by their tobacco. If it didn't bring a good price, the warehouseman would declare, "This widder lady has these younguns to feed—you got to do better than that, fellers" and run the buyers by again.

My old friend Billy Yeargin in Four Oaks probably knows more about tobacco culture, history and the auction system than anyone. He came out of a warehouse family also. His father was the straight-laced owner of Yeargin's Tobacco Warehouse in Oxford for thirty-one years. Billy held a number of major positions in the tobacco industry, and he now dubs himself the "World's Only Tobacco Historian." For a walk down memory lane, visit his website www.tobaccoheritage.com.

Billy deals in real estate and teaches a course in tobacco history (Southern Culture) at Duke. Billy knew the world's most famous tobacco auctioneer, L.A. "Speed" Riggs of Goldsboro. Riggs was "the voice of Lucky Strike," and his mind-boggling chant was heard in the Lucky Strike radio ad that always ended with the lilting, "Sold to American!" He drew big bucks for personal appearances.

The local unemployed—usually a hardened, scruffy bunch—flocked to the warehouses for the seasonal jobs. They loaded and unloaded, cleared the auction floor and moved tobacco to areas reserved for buyers and did the grunt work that kept the auctions running. Then in the wee hours of the morning, in the dim light of the dusty warehouses, they would pass jars of bootleg whiskey between them, shoot craps and pick up spare change by directing farmers to local shot houses and selling a pint or two of liquor themselves.

Till lately, tobacco ruled the roost in North Carolina. Former Governor Bob Scott doggone near committed political suicide once by declaring publicly, "Tobacco is no longer king in North Carolina."

Tobacco got President Jimmy Carter in a bunch of trouble, too.

He appointed Joseph Califano Secretary of HEW, and Califano immediately went on an anti-tobacco crusade. As the general election of 1978 approached, North Carolina farmers were so mad at the Democratic Party, it looked like the Republicans would easily sweep the state. Then Governor Jim Hunt and United States Senator Robert Morgan decided they had better do something. Hunt was coming to Washington for a governor's conference, I believe, so Morgan, who was close to Vice President Walter Mondale, called Mondale and asked if he and Hunt could see him. Mondale obliged.

They gave him an earful, telling him that if Carter didn't come to North Carolina and make up with tobacco farmers, the Democratic Party was down the tubes and Carter would never win the state again. Mondale carried their water for them, talked to Carter and got a commitment from the president to visit North Carolina—Wilson, North Carolina, the world's largest flue-cured tobacco market—on August 5 and attend a tobacco auction.

I have one of the original fliers in my hand right now. "Open to the General Public. COME SEE & HEAR President JIMMY CARTER. FREE. WILSON COUNTY LIBRARY. Saturday, August 5, 1978. 12:15 PM."

North Carolina Tobacco

Illustrious Agriculture Commissioner Jim Graham converses with President Jimmy Carter during a break in the sale at a warehouse in Wilson, North Carolina. This was one of the first times in decades that a sitting president had visited a tobacco auction. Carter's stock among tobacco folks rose high and fast as a result. However, the president might have left the area with many questions in his mind about room preparation. *Photo courtesy of the* Flue-cured Tobacco Farmer *magazine.*

There was a problem: the tobacco warehouses were closed on Saturdays.

A number of congressional staffers, including Doug Copeland, who is now the publisher of the *Business Journal* in Greensboro, and I were dispatched to the state to advance the trip. Prior to leaving, I prepared a briefing book for the president on the political situation in North Carolina, including some rather straightforward comments about the candidates. I have the rough draft, and it is destined for the East Carolina University Library and its impressive North Carolina collection.

They farmed us out around town, and Dr. John Costable, an optometrist who loved politics and raised a pile of money over the years for candidates, gave me a bedroom. Our first task was to organize a mock tobacco auction—a media event—for the president prior to his speaking on the grounds of the Wilson County Library and attending a luncheon at the Heart of Wilson Motel.

"Between You and Me"

James A. Graham, North Carolina agriculture commissioner (1964–2004), loved cowboy boots (he wore a size 13 boot) and Stetson hats. As a gesture of friendship, he gave this author one of his "surplus" hats in 1977. This old hat was moved from office to office, attic to attic and storage to storage, until, in 2004, after Graham's long term in office, the hat was taken to Wallace Photography Studio in Smithfield, North Carolina. Dressed with two bundles of tobacco, Tim Wallace and I created a photo depicting an image that, without a doubt, Graham would be proud of. *Photo courtesy of Wallace Photography Studio, Smithfield, North Carolina.*

We did it with aplomb. We called tobacco farmers who were Democratic Party stalwarts—folks like Judge Gerald Arnold's father—and asked them to load up their trucks with their best leaf and bring it to Wilson. They did, and on August 5, 1978, Champ Batchelor, one of the world's best auctioneers, started the chant and conducted a tobacco auction for President Carter, Commissioner of Agriculture Jim Graham and a host of other high-ranking officer holders.

Billy Yeargin was right in the middle of it. He says that Jim Graham, who loved a camera, stopped the auction dead at one point to make sure the photographers were getting him in the photos with the president.

There were only a couple of small hitches. The town was crawling with Secret Service agents for days, making various demands—most unreasonable—and at one point they told local officials that an ancient oak tree on the lawn of the library had to go because it would create a security risk during the president's speech. The locals rebelled, and the old oak is still standing.

The second hitch occurred late the night before Carter was to arrive. Everything was done that could be done, and we were sitting around Doug Copeland's at the Heart of Wilson congratulating ourselves on a grand job. The same room would serve as the "holding room" for the president when he arrived at the motel the next day. Then we all started scratching. Guests—let's lay it to the Yankee tourists—had slipped their pooch in the room, and it was infested with fleas. The details were etched in stone by that time, and Carter would be in the room the next day come hell or high water…fleas or no fleas.

There was nothing to do but rouse an exterminator from his bed, hose down the room and pray.

The next day, we watched more intently than most while President Jimmy Carter made his luncheon speech. Between you and me, he didn't scratch nary a time.

"Question & Answer with Pender Sharp"
by Rocky Womack

Tobacco News: The buyout is long over, and we are a few years into operating without a federal quota system. Do you believe the buyout accomplished what it should have?
Pender Sharp: I don't think I've ever witnessed a system that's worked any better than the buyout has. The proposals were for a lot more money over a shorter period of time, but the tobacco buyout, as it is, still removed 90 percent of the stakeholders in the tobacco business. It left the entity to growers, manufactures and dealers to decide who as a tobacco family will be doing this in the future.
Tobacco News: Where do you think the industry is as far as competing in the world market?
Pender Sharp: I get a warm feeling talking with manufactures and dealers. U.S. tobacco will always have a prominent place because of its desirability. With the rollback of prices, we seem to be gaining some eroded share of the market over the past few years. The economy in Brazil and poor quality crops coming out of there in the last three years make U.S. tobacco attractive worldwide.
Tobacco News: What have you done to improve efficiency?
Pender Sharp: Many growers chose to leave the industry. Those who stayed have acquired a comfort level with investing in the future of this crop. Here at Sharp Farms, we are optimistic about the future of tobacco in the United States. We have chosen to invest in equipment in order to increase our capacity and save labor. For 2006, we purchased an automatic box loader and a dry tobacco handling system. We added on more barns and automatic curing controls.
Tobacco News: How do the automatic curing controls make your operation more efficient?
Pender Sharp: It definitely will save on fuel costs. The automatic curing controls monitor our barns around the clock when we're not there. It keeps the wet bulb and dry bulb at a constant setting and keeps barns progressing as they should be. That peace of mind should be worth something.

Pender Sharp.

"Question & Answer with Pender Sharp"

Since the beginning of the loose-leaf auction in 1858, many changes have come about. However, as the old saying goes: "The more things change, the more they stay the same." This is evident in the way tobacco is now being sold. Notice the bales, which illustrated the last change in the method of marketing in more bulk, as compared to previous methods such as the sheet, and then the basket, both of which were methods used to sell tobacco until the mid-1960s.

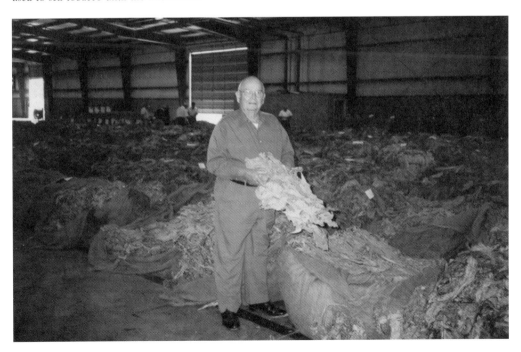

Wilson Crabtree, noted tobacconist, now retired from American Tobacco Company, stands by a bale of tobacco during a live auction held before the Loan Support and Control Program.

Three generations of Yeargins.

Tobacco News: How do growers succeed in today's tobacco environment?
Pender Sharp: You've got to have the mindset to be a least-cost producer. It's the Wal-Mart theory. We've got to be able to provide to our customer the best quality of tobacco for the least cost and do that in volume. The buyout has enabled growers to head down that road and accomplish those goals.
Tobacco News: How does a grower become a least-cost producer?
Pender Sharp: There are two factors that determine profit or loss—labor and fuel. They are the two biggest costs we have. You've got to address the two biggest paradoxes in your budget.

We're about as automated as we can get. Other than suckering, the only time we touch tobacco by hand is when we put it in the trans-planter. We invested in equipment to go from the greenhouse to the warehouse at pennies per pound in labor cost.

Looking at fuel costs, we've done two things. We've invested in bulk storage so we can buy fuel in transport loads at ten thousand gallons at the time. That's a tremendous savings. And with the curing controls, our curing efficiency has increased as we try to save as much fuel as possible.
Tobacco News: You've been able to mechanize and have the level terrain to use this equipment, but what about the Piedmont North Carolina and Virginia growers who find it hard to mechanize because of the hillier terrain and smaller acreage?
Pender Sharp: The grass always looks greener on the other side of the fence. We, too, are hampered by small fields in some areas of the coastal plains. Our average in 2006 was 6.1 acres of tobacco per field. Mechanical harvesters may be more adaptable than you think. However, considerable attention to details in one's cultural practices is mandatory. Dry leaf handling systems work anywhere. Bottom line is, regardless of where we farm, we must reduce our cost to maintain profitability!

Compliments Of #764
Yeargin Warehouse
W. W. Yeargin III – Owner & Operator
Oxford, N. C. 27565
Telephone: (919) 693-7723

1997 LOAN RATES

B1L -190	B3KR -179	B4G -152	C1F -177
B2L -188	B4KR -175	B5G -144	C2F -175
B3L -186	B5KR -166	B4GK -150	C3F -173
B4L -184	B3V -177	B5GK -142	C4F -167
B5L -176	B4V -171		C5F -159
B1F -190	B5V -164	H3F -186	C4KR -160
B2F -188		H4F -184	C4V -157
B3F -186	B3KM -173	H5F -176	C4KM -156
B4F -184	B4KM -170	H4FR -182	C4KL -154
B5F -176	B5KM -163	H5FR -175	C4KF -154
B1FR -189	B3KL -169	H4K -179	C4G -142
B2FR -186	B4KL -165	H5K -171	C4GK -138
B3FR -185	B5KL -155		
B4FR -182	B3KF -169	C1L -177	X1L -171
B5FR -175	B4KF -165	C2L -175	X2L -163
	B5KF -155	C3L -173	X3L -159
B3K -181	B4KV -159	C4L -167	X4L -148
B4K -179	B5KV -149	C5L -159	X5L -134
B5K -171			

The "loan rate" card explains to the farmer, as well as anyone else, how the loan support functioned, broken down on a grade-by-grade basis. These cards were given out complementary by the warehousemen. The card shown here was printed and distributed by my son, W. "Billy" Yeargin III (mostly known as "Dooster"), who owned and operated Yeargin Warehouse and was one of the hardest-working and most aggressive warehousemen and tobacconists of his generation. Unlike most former tobacco warehousemen, Billy chose to maintain a close "post-warehouse" relationship with farmers of his area by providing a produce auction, as well as a farm chemical and implement sales and service.

Tobacco field day for the government administrators of the Loan Support and Control Program. Officials visit the Farmville, North Carolina auction markets in 1979. *Left to right*: Jim Graham, commissioner, North Carolina Department of Agriculture (NCDA); Ed Yancey, regional director, NCSU Cooperative Extension Service; Jim Hunt, North Carolina governor; John Cyrus, chief of Tobacco Affairs, NCDA; unidentified USDA official; and Billy Yeargin, executive director, Tobacco Growers Information Committee, Inc.

Other minor amendments for flue-cured and several for burley tobacco were also included in this 1983 package.

Thus, as the curtain falls on the first fifty years of the tobacco program, the whole tobacco industry can look back with pride at the most successful, most effective and most efficient farm program ever developed in the United States of America, with the least cost to the government of any other government farm program on record.

Note: Reprinted with permission from Pender Sharp and Rocky Womack. Pender Sharp owns Sharp Farms Inc., located in Sims in Wilson County, North Carolina. Along with his son Thad IV, his father Thad Jr. and his brother Alan, Sharp produces flue-cured tobacco, cotton, sweet potatoes and soybeans and raises hogs. Womack is a doing business as Rocky Womack Communications.

"Hicks Honored by Stabilization"
from *Flue-cured Tobacco Farmer* Magazine

His sole concern has been the economic welfare of the farmer.
That statement of praise and many others of tribute were heard by Carl T. Hicks last month as he stepped down after thirty-two years as president of the Flue-cured Cooperative Stabilization Corporation. Hicks was honored during Stabilization's annual meeting held in late May in Raleigh.

The statement above was made by Colonel William T. Joyner, general legal counsel to Stabilization, and longtime associate of Hicks in farm-policy-making organizations. Joyner's tribute was one of two official statements in honor of Hicks during the meeting; the other was delivered by Mrs. Irby Walker, secretary-treasurer of the North Carolina Farm Bureau Federation. Other speakers added their comments of praise of Hicks and referred to the immeasurable value of his contributions to the tobacco-growing business.

Outstanding Service Praised
Joyner officially bestowed on Hicks the Outstanding Service Award given by Stabilization to Hicks "for his loyal service as President and Director from June 1946 to May 1978. Through his foresight and leadership, he helped to organize, create and guide this organization through these years." Hicks was recognized by being named "Honorary President Emeritus of Flue-cured Tobacco Cooperative Stabilization Corporation for the duration of his life." The statement was inscribed on a plaque presented to Hicks.

Hicks's successful leadership of the tobacco program was attributed to "the inspiring and effective exercise of at least four basic fundamental talents with which he is endowed: they are Intelligence, Integrity, Courage and complete Dedication to the welfare of the tobacco grower and the providing for a fair market for his products," Joyner emphasized.

He went on to say about Hicks, "It is that last talent [dedication] which has been outstanding and continually observed as his programs made progress. Carl Hicks has always put the grower first ahead of himself and ahead of any other objective. He has given of himself without restraint."

Carl T. Hicks was honored by Stabilization by being named "Honorary President Emeritus of Flue-Cured Tobacco Cooperative Stabilization Corporation for the duration of his life."

Hicks, now seventy-eight, was described as one who "has loved his fellowman, and has toiled for his welfare! He has earned and he has received the utmost respect from all of the people with whom he has worked. He has earned for Stabilization a prestige which is a tremendous asset to it."

Mrs. Walker, herself active in farm matters for decades, and the keeper of many records and books, was present at the initial organization meeting of the Flue-cured Tobacco Cooperative Stabilization Corporation, and accepted the very first application for a membership certificate in Stabilization, which, of course, came from Carl T. Hicks, who was granted membership card number one! During the annual meeting last May, Mrs. Walker returned Hicks's original card to him as a memento of his long years of great service to Stabilization.

Stabilized Prices Proposed

Thirty-two years ago, in May of 1946, Carl T. Hicks made his proposal for the establishment of the flue-cured tobacco stabilization body during a North Carolina Farm Bureau meeting, saying that the stabilization body "would guarantee keeping the floor under tobacco almost up to the ceiling price allowed," which, by definition, is "stabilization." Hicks stressed the point that the purpose of the proposed corporation was to keep farmers from going into bankruptcy, and not for making money. He was made temporary chairman of the proposed new body. At that time Hicks had already been acting as the chairman of the Farm Bureau's Tobacco Advisory Committee, a post that he held for twenty-eight years.

Hicks got involved in tobacco marketing issues as early as 1933 when he organized farmers to control supply and demand through the limitation of plantings. During the Depression, leaf prices dropped to almost nothing, and Hicks's efforts at getting growers to cut back voluntarily were so successful that prices doubled. After a trip to Washington by Hicks and other farm leaders, the government agreed to support prices if growers did, indeed, sign up for a crop reduction. Even then Hicks was thinking about some sort of program that would ensure the orderly and profitable marketing of tobacco, an idea that came to life as the Flue-cured Cooperative Stabilization Corporation.

Stabilization was formed in June 1946, with Hicks as president, the late E.Y. Floyd as temporary secretary and the late Lloyd T. (Tubby) Weeks as the first general manager and secretary-treasurer. The office was located in the old Blount Building in Raleigh.

Regarding the value of Stabilization's contribution to tobacco growers, the market value of the thirty-two tobacco crops sold since it began operating amount to $25.7 billion! Hicks intensifies that money figure by saying, "Based upon my experience as a tobacco grower prior to 1946, I would say that figure is THREE times the amount those crops would have brought if they had been sold without a support price." He believes that the price support program has been worth more than $17 billion to flue-cured tobacco growers over the past thirty-two years.

Dedicated Concern

Carl T. Hicks (Mrs. Walker said in her tribute that the initial "T" in Hicks's name stood for "tobacco") was one of the first farmers to be concerned about the smoking and health issue so he got busy and formed the Tobacco Growers Information Committee, Inc., and served as it's president for fourteen years. He was also concerned over the ever-escalating taxes on cigarettes many years back, and helped organize the Tobacco Tax Council, Inc.

Hicks has lived in Walstonburg in Greene County, North Carolina, since 1920, where he has engaged in large farming businesses and other enterprises. An active member of the Lions Club and the Masonic Order, Hicks served as state senator from his district for four terms, was an organizer of the Walstonburg Methodist Church and served as chairman of the Green County Board of Education.

Note: The key to the success of the American tobacco industry, throughout our history, has been impeccable leadership. In the colonial era, George Washington and Thomas Jefferson, just to name two, are the most recognizable examples of this theory. For most of the twentieth century, a handful of leaders steered the industry along a stable and steady course. Carl "Tobacco" Hicks of Walstonburg, North Carolina, is probably one of the most renowned leaders of his day. He helped found the Flue-cured Tobacco Cooperative Stabilization Corporation and served for an extended period as its president. Upon his retirement from the cooperative board, Hicks was featured in the *Flue-cured Tobacco Farmer* magazine. This tribute is a well-deserved one for Mr. Carl T. Hicks. Story and pictures courtesy of the *Flue-cured Tobacco Farmer* magazine, Special Issue, mid-June 1978, reprinted with permission.

"Remarks to Tobacco Workers' Conference"

by J.T. Burn

Who would have surmised that in twelve months our industry would be thrust into a system without price support, without mandatory grading, without mandatory testing, without market information, without government guarantees and without further congressional benevolence? Who could fathom the abrupt dismantling of the convoluted tobacco program that operated for two-thirds of a century?

The answers to these questions are plain: we knew it had to happen in order to continue a supply of U.S. tobacco. Fortunately, as the Tobacco Quota Buyout Legislation engaged and old laws and regulations expired, economic forces reentered our industry.

We witnessed the beginning of a free market, the beginning of new risk management, the beginning of a new competitive position, the beginning of renewed customer interest, the beginning of opportunity for production expansion, the beginning of grower exit options and the beginning of new purchasing strategies by customers.

We are all in the midst of this transitional avalanche and all segments of our industry are grappling for direction and focus toward customer demands and producer capabilities. The regulatory barriers are gone and now the logistical and economic barriers have become the challenges of today.

As we survey our new position, our competitors are keenly observing our actions. If the United States expands leaf exports, most likely our competitors will feel the impact of losing market share.

During January of 2005, I had the privilege of visiting the main tobacco area of Brazil in conjunction with an agriculture tour of Brazil hosted by the North Carolina Farm Bureau. This tour provided a startling firsthand view of the tremendous agricultural production capacity of Brazil, which is slightly smaller than the United States. From my observation, Brazil will dominate or greatly influence world markets for many agricultural commodities including sugar, coffee, cotton, soybeans and tobacco, just to mention a few.

North Carolina Tobacco

Frank Lee, one of North Carolina's leading and most enduring tobacco marketing experts, posing in front of tobacco recently received at his collection station.

Tobacco farming in Brazil is often characterized by small family farms that operate similar to the way U.S. farmers managed production in the 1950s era. The small tobacco farms do lend themselves to using family labor and manual labor production techniques. The small acreage units are successful to the point of making Brazil the largest exporter of flue-cured tobacco in the world.

The major advantage I noticed in Brazil involves the curing of tobacco with wood and the plans to continue this renewable energy source. And if the current economic units become obsolete or the labor is not available, technology is readily available to step in as needed. There will not be a lag time to research and develop needed mechanization and technology because it is already on the shelf.

Brazil has a large farm equipment manufacturing base and our tour visited a tractor and equipment manufacturing plant and saw the tractors used in U.S. tobacco fields being made in Brazil. Resources are available to Brazil's agricultural industry.

On many of the cotton and soybean farms, a fleet of sprayer airplanes usually occupied storage buildings adjacent to warehouses, and sheds of modern planting and harvesting equipment were in the barnyards. After visiting some agriculture research facilities, I certainly had to rethink my image of Brazil as a developing country.

The vast amount of virgin farmland that is available in the frontier areas of Brazil may not be suited for tobacco production as we know tobacco production. But some gutsy group of farmers could give it a try. The take away here is that Brazilian competition is not out of options just because we are back in the market.

To trace our 2005 movement, we must recognize that our industry has little experience in dealing with free market conditions. Our production and marketing structure is designed around a rigid quota system. So, the perplexing question was and is, do we <u>renovate</u> or do we <u>build a new</u> production and marketing structure?

Well, the timeline between enactment of the buyout legislation and the start up of the 2005 production did not accommodate very much long-term planning, so we tweaked our established structure and moved into our first free market season in 2005.

Now, here we are with year-one production and flue-cured marketing wrapped up and burley marketing is moving along in a free market environment. What is next for leaf exports? How is the leaf export trade responding at this juncture to our new price and value position?

I posed these questions to some U.S. leaf exporters recently and had some cautious responses that I will share with you today.

The European commitments so far are static with the previous season interest and at least there is <u>no</u> apparent continuation of the downhill market slide for the European customer base.

It appears that most of the European leaf customers are taking a wait and see position on the capabilities of the U.S. producers in a free market system. There are some emerging factors that favor U.S. leaf in the European market. One is the decline of Zimbabwe as a reliable supplier of leaf. Second, the two consecutive dry seasons in much of Brazil diminished Brazil's leaf quality and will likely cause a reassessment of European manufacturers' positions in that market; this is especially true for our German customers.

North Carolina Tobacco

The modern-day method of marketing now involves bringing tobacco to be sold at a designated collection station. Here Frank Lee shows off the high quality tobacco received at Central Marketing, his collection station in Smithfield, North Carolina.

Tommy Bunn of the Flue-cured Tobacco Cooperative Stabilization Corporation, Inc. is one of the few contemporary tobacco leaders whose pedigree includes growing up on the farm and climbing through the ranks of the industry ladder, one rung at a time.

"Remarks to Tobacco Workers' Conference"

When you look at customer interest in diversifying supply, along with the increase in the value of the Brazilian real compared to the U.S. dollar, and the lower U.S. leaf prices, I feel we can anticipate an uptick in leaf sales to some European customers within the next two to three years.

The prospects for increased U.S. leaf sales to the Asian market are more volatile and dramatic. The Thailand government cigarette manufacturer has expanded its interest in buying U.S. leaf. Encouragingly, our lower prices have increased Thai orders from the 2005 crop, but we need to finish the story. The Thais have implemented new purchasing procedures along with the intentions to purchase more U.S. leaf.

First, a significant percentage of the Thai order will not be paid in currency. Instructions from Thailand required leaf dealers to accept payment in the form of Thai export goods that are in surplus and are on the Thai government list of goods that can be exchanged.

So, U.S. leaf merchants will also become exporters of Thai surplus goods such as olds stocks of rice. We can only imagine the brokerage fees and price discounts that will accompany these counter-trade deals.

It does not stop there. The Thais used an E auction to purchase their orders. Now this sounds innovative unless you add to the mix that the E auction was scheduled after the marketing season closed.

Can leaf merchants buy inventory from a crop on speculation to supply an after the season E auction customer? At best, inventory speculation is a highly risky business and the tobacco trade is filled with many financial horror stories involving inventory speculation.

What happened at the E auction? The criteria for qualifying to participate in the E auction could not be met by U.S. leaf companies. It is my understanding that a Thai company did qualify and was awarded the bid for the 2005 flue-cured crop orders.

The problem here is that with the apparent manipulation of the purchasing process, the new value competitive position of U.S. growers has been compromised away. Our Thai customer's U.S. leaf cost did not reflect 2005 U.S. price reductions. This creative manipulation of the supply process may undo and damage our efforts to regain market position. Of course, we have little leverage in another country unless our trade agreements address such situations. This situation can stand some scrutiny, but we must make sure it does not spread to other customers.

China is another Asian source of opportunity for U.S. leaf. China tobacco industry representatives were here in mid-October. They have bought small purchases over the past two seasons from burley and flue-cured and the word is they bought a significant volume of flue-cured and some burley on this trip.

With the Chinese preference for lighter styles it is difficult for them to find the lighter tobacco they like late in the selling season. The dry, late summer harvest seasons also reduce the availability of light tobacco in flue-cured. Burley producers appear to have "growing" opportunity to supply the China market as the blended product market expands in China.

While the leaf merchants are very conscious of the Chinese leaf–style preferences, price is often the dominant factor in determining the style of tobacco the Chinese actually buy.

A new factor is playing in our favor with the Chinese market. Yes, our prices are lower. Also, the Chinese yuan is no longer fixed to the U.S. dollar. In 2005, the government of China allowed the yuan to be tied to a basket of international currencies that included European currencies. The value of the yuan has been allowed to rise slightly, thus favoring U.S. purchases. So, goods from China will likely become more expensive and U.S. leaf will become less expensive for the Chinese. All these projections play into a scenario that China will need to import much more leaf in the future to meet increased blended product demand and the U.S. can supply a portion of these needs at affordable prices. If we can supply China in a meaningful way, we can expect a sizeable escalation in U.S. production.

Japan's interest in U.S. leaf goes back more than a half century. They have been supreme customers of U.S. leaf tobacco and very stable in their purchasing patterns. This year is no different. The Japan Tobacco purchasing plans are the product of long-range planning. We hope that Japan Tobacco will fully consider the increased value of U.S. leaf in their long-range planning and consider using more of our leaf tobacco in their products.

The opportunities to export U.S. leaf are still prevalent and competition is still keen; however, our position in the market has improved for exports and for the domestic markets. Price will continue to be the leading factor that sells U.S. leaf.

However, we must consider other factors that plug into the long-term value equation, such as:

 The high quality of U.S. leaf
 The shortage of high-quality Burley leaf
 Source diversification of leaf supply
 Stable production environment
 More favorable currency exchanges rates
 Contractual supply management

Additional factors for the domestic market include:
 No ocean freight cost
 No tariff rate quota limits on domestic supply

We merge these equation factors and contemplate the results for 2006. The extraneous factors that leave the results cloudy for the short run is the disposition of inventory owned by the cooperatives. These are sources of leaf that could still displace production.

The cost basis in these cooperative inventories could allow them to be sold at less than market price, and until depleted, these inventories will be viewed as competing with U.S. productions. Of course, we know these inventories can help supply off-season customer purchases in the short run.

We have heard estimates of a 700-million-pound flue-cured crop in Brazil for 2006. If the Brazilian crop is in fact that large, it will likely impact the need for U.S. flue-cured in 2006.

U.S. burley is a different story. Since there is still unmet demand for high quality burley leaf, we will likely have a stronger interest in increasing our burley production in 2006 in traditional and nontraditional areas.

The short run outlook is still partially driven by remaining cooperative inventories, but long-term we see renewed potential for U.S. leaf use in the export and domestic markets and the watchword to remember is "China."

Another item on the watch-closely list is the Doha round of World Trade Organization negotiations. The ministerial trade talks in Hong Kong were not productive. This round is critical for agriculture since market access, tariff rate quotas and duty reductions negotiations will most likely set the stage for a new WTO agreement in 2006, but compromise is scarce. Many of our trading partners have strident negotiators who are trying to hang onto favorable subsidies and tariffs.

Time is running out for the Bush Administration to accomplish a new agreement. We lose fast track authority in July of 2007 and if a few seats in Congress are moved to the Democrat side in the 2006 elections, the president may not be able to get fast track through Congress for the last two years of the Bush Administration. Market access for agricultural commodities, including tobacco, is the linchpin to our progress, especially for leaf tobacco.

So, again, timing is everything and if we miss opportunities in the Doha round, they could be gone for good. Future trade talk may focus on industry and technology as they have in past rounds. We must not let agricultural opportunities be compromised in favor of gains for other industry sectors.

I want to mention the Golden Leaf Foundation's contribution this season in the form of a grant to fund research on burley production in <u>nontraditional areas</u> of North Carolina.

An amount totaling $264,800.00 was granted through North Carolina State University's Tobacco Foundation to do work on several projects, including disease resistance, curing methods and educational sessions for new growers. There appears to be continuing interest in producing burley in the Piedmont area of North Carolina and Virginia. This step could be the beginning of redefining tobacco territory.

Our new direction for the U.S. industry is faced with many profound decisions that will dramatically mark our progress. First, we must be competitive. Next, we must be able to supply our customers with high-quality tobacco. We especially need to maintain an industry base that can make our <u>economic contribution be noticed, appreciated and respected.</u> To accomplish all of this, we must <u>sell</u>, not cut, but <u>sell</u> our services and our products into prosperity. The scientific base the Tobacco Workers' Conference represents is the leading edge in this pursuit.

Regardless of our station, position or title, all of us in the U.S. tobacco industry must include selling U.S. leaf as our mission.

Note: J.T. "Tommy" Bunn is one of a dying breed of tobacconists who learned his trade from the ground up—and from the inside out. As a child of North Carolina's tobacco farming culture, he knows what it is like to scrub tobacco wax from his hands before going to the dinner table. And he has spent endless hours stumbling along between two tobacco rows, staring at the north end of a mule pulling a southward-bound plow.

Tommy rose from the Goldsboro loamy (and sometimes red clay) tobacco fields of the Tarheel state's eastern Piedmont to successfully command many critical positions in the industry. He ultimately has become one of the most respected tobacco icons of his generation.

This excerpt, taken from Tommy's "Tobacco in the 21st Century," delivered January 16–19, 2006, speaks to those coming generations who will formulate what will become the tobacco history of the twenty-first century. Reprinted with permission of J.T. Bunn.

Tobacco Terms

aphid n.—a small insect that sucks a tobacco plant, also called lice.
auction n.—after tobacco is pulled and dried it is taken to a warehouse to be sold to the tobacco company that offers the highest bid.
auctioneer n.—the person at the auction who usually tries to get the highest price possible.
basket n.—a shallow container in which tobacco is put in a warehouse.
black shank n.—a disease that tobacco can catch.
bloom n.—the flower on the tobacco that is broken off so the leaves can grow.
blue mold n.—a disease that gets on tobacco in wet seasons.
breaktime n.—a time when work is stopped in order to rest for a few minutes and have a snack (some type of biscuit; tomato, fatback or molasses) and a drink.
bud n.—new growth of a plant.
bud worm n.—a worm that lives in the top of a plant and eats the bud.
bundle n.—a neat handful of green tobacco leaves put together with all stems even, to be tied on a stick, or a group of dried leaves tied together.
catch up v.—to get all the green tobacco at the barn strung before another slide comes in; when this occurs it is assumed that the workers at the barn are working harder than those in the field.
cooping up v.—packing tobacco in chicken coop fashion so more air can circulate around it.
cure v.—heating green tobacco that is hung in a barn so that it becomes dry; must be done before it can be sold.
cutters n.—the second pulling of tobacco.
cut worm n.—a worm that cuts a young plant off at ground level.
draw plants v.—to pull plants from a tobacco plant bed to be transplanted in fields.
drive slides v.—to be in control of a mule or tractor that is pulling a large container that transports tobacco leaves from the field to the barn.

drop plants v.—to plant small tobacco plants, which have been taken from a plant bed, in the tobacco field.
five-room barn n.—a barn often made of logs that has five sections where tobacco is hung on poles and dried; the tobacco is put on sticks first.
flue-cured adj.—a type of tobacco dried by the use of a fuel-like gas or wood.
grade v.—to separate tobacco into groups by quality and color, usually three groups: good, green and shacks.
ground leaves n.—leaves on the bottom of the stalk that are pulled first; don't bring much money.
hand leaves v.—the act of giving leaves, usually about three, in a neat bundle with the stems even, to a person who strings them on a stick.
hogshead n.—barrel for putting tobacco in to be shipped.
hoist v.—to put tobacco that is on a stick in a barn on the tier-poles, most often pronounced heist.
holding sticks v.—in days of cutting tobacco, one person had to hold a stick while another put the cut tobacco plant on it.
in order adj.—tobacco that has been cured and has the right amount of moisture, usually measured by squeezing a few leaves; only experienced farmers can accurately determine if the tobacco is in order.
killing out v.—to get the moisture out of stems by using very high heat; the last stage of curing.
lay-by v.- to cultivate tobacco for the last time.
leaf n.—the leaves on the top of the tobacco stalk.
lugs n.—the tobacco on the bottom of the stalk.
mule n.—a large, strong animal, which is a cross between a horse and a donkey, used for heave work on the farm, such as pulling slides.
packinghouse n.—a large building where cured tobacco is stored until the farmer can get it ready for the market.
plant bed n.—a little piece of land covered with plastic in which a farmer plants tobacco seeds and nurses them until they are big enough to plant in an outdoor field.
price support n.—the guaranteed price for all tobacco.
prime v.—to harvest tobacco.
primings n.—leaves that are better.
pull v.—the process of breaking off leaves from a tobacco plant.
recoop v.—to take dried tobacco out of one coop and put in another.
shacks n.—lower quality tobacco taken out during the grading process done in the packinghouse.
sheet n.—burlap material used to transfer tobacco to the warehouse; v. to take dried tobacco off the stick and pile it in a large piece of burlap to be carried to the market.
side-dress n.—nutrients added to the initial fertilization that usually is applied with first cultivation.
sleeping at the barn v.—a term used to explain an event that occurs during overnight curing of tobacco.

Tobacco Terms

slide n.—an object used to carry tobacco from the field to the barn, usually pulled by a mule or tractor.

speculator n.—an independently employed person who buys tobacco at a low price and then tries to sell it at a higher price; also called a pinhooker.

stalk cutting v.—in old days farmers cut down the whole tobacco plant and hung it in a barn to dry.

stringing horse n.—a wooden structure used by a person to string tobacco on a stick; usually homemade.

stripping v.—taking dried tobacco off the stick to be prepared for market.

sucker n.—an outgrowth on the side of a tobacco plant that farmers have to cut in order for the tobacco to grow.

sweep out v.—to use a broad plow to clean out the middle of a row.

swell stems n.—when the stem of a cured tobacco leaf is not properly dried out; v.—1. to put green tobacco together in small bundles on a stick; same as string. 2. to put together larger bundles of dried tobacco.

tie leaf n.—a good leaf used to put around a group of dried leaves to make a bundle.

tier pole n.—poles in a stick barn about four and a half feet apart used for hanging sticks of tobacco to be cured; black snakes or their skins are often found on the poles at the top of the barn.

tobacco barn n.—a building often made of logs with a dirt floor and tier poles, used to cure tobacco.

tobacco stick n.—a rough piece of wood about four and a half feet long and an inch in diameter used for stringing tobacco so that it can be hung in a barn to be cured; often has a lot of splinters.

tobacco wax n.—a sticky, black substance on tobacco plants that will stick to a person's hand while handling tobacco; the amount of wax on one's hands is often an indication of how hard one has worked.

top v.—to break off the bloom of a tobacco plant so that the minerals can get into the leaves to make them bigger.

top dress n.—extra nutrients applied during initial cultivation, about ten days after planting.

turning out a sucker v.—leaving one sucker to allow a tobacco plant to grow larger in order to prevent stunted growth, which is caused by premature flowering.

turn the slide over v.—when the slide that is carrying the tobacco from the field to the barn is turned over and leaves scatter everywhere; people at the barn usually get angry when this occurs.

turn the ticket v.—to reject a bid that has been offered for a pile of tobacco.

wrappers n.—big, nice leaves used to make cigars.

Note: This glossary consists of some of the entries that appear in "A Tobacco Dictionary for Person County," prepared by students from Woodland Elementary School and published as "Laying-by, Turning Out, Cooping Up: Tobacco Industry Has Its Own Jargon, Mysterious to Uninitiated" by the *Roxboro Courier Journal*.

Visit us at
www.historypress.net